A Guide to Drawing
Manga Fantasy Furries

and Other Anthropomorphic Creatures

Ryo Sumiyoshi

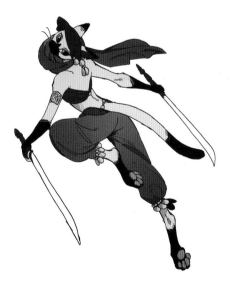

TUTTLE Publishing

Tokyo | Rutland, Vermont | Singapore

Contents

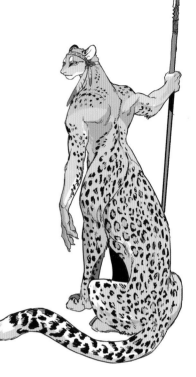

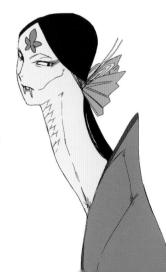

CHAPTER 4
Anthropomorphized Arthropods

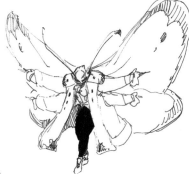

CHAPTER 5
Anthropomorphized Fish

Tips and Interview

Why I Wrote This Book

It's been more than fifteen years since I decided to strike out on a path as an artist and focus on anthropomorphic characters to put food on the table. During that span of time, I've gotten a lot of experience drawing all manner of hybrid creatures. It is my hope that what I've learned through my work with manga, anime, videogames and other outlets—as well as insights into the different media and the universal motifs that I gravitate toward—will guide and inspire you in your artistic journey!

Thank you for choosing this book.

—Ryo Sumiyoshi

CHAPTER **1**

Drawing Anthropomorphic Characters—The Basics

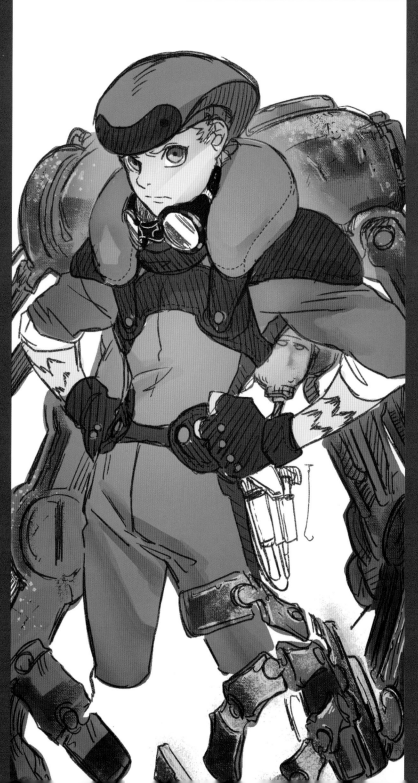

In this chapter, I summarize the basic knowledge you need along with tips on how to draw anthropomorphic characters. I cover a wide range of aspects, including creating and conveying facial expressions, modeling, deformation and sketching methods. I also take into consideration the different methods required, depending on the medium, to develop hybrid characters from animals.

Differences in Presentation According to Genre

Although "character" can be summed up in one word, each one can be expressed in various ways, depending on the genre. What type of presence do they have and what role do they play? We need to think about the range of possible expressions.

I'd like to start by saying there is no right or wrong when it comes to drawing. That's where it can get confusing. I don't intend to tell you in this book that you shouldn't draw in certain ways.

However, if you're required to draw a character as part of your work, you need to be aware of the different expressions expected for each medium. You could draw a truly amazing illustration, but if the style of character drawn isn't appropriate or doesn't meet the target audience's expectations, it will fail. Being well-drawn doesn't guarantee success.

So here I'll briefly explain the type of expressions that are required, and desired, in each medium.

Unmodified wolf

Portraying Animals and Humans in Manga

Manga has a wide range of expression and gives the artist a lot of freedom. You can include a lot of realism or you can go with super deformation. What's important here is knowing what you want to convey. If it's a depiction of nature, it's fine to express an animal as it is, without adding any anthropomorphic facial expressions. But because it's going to be humans reading the manga, it's crucial to have an intermediary (a human character) who can convey the appeal of the story to the readers. So, rather than only drawing what you are comfortable drawing, for the sake of your work, you need to challenge yourself to draw expressions that are difficult or unfamiliar.

Hunters or researchers make convenient narrative intermediaries.

Manga for Portraying Only Animals

It's also possible to illustrate a story using only animal characters. In that case, if you can portray human facial expressions and gestures for communication, that is a powerful tool. This is what is known as "anthropomorphism." Its original meaning is to add deformation to something so that it takes on human attributes. Manga has a great deal of freedom in expression. That's why I think it's important to be interested in a variety of elements and study them in order to draw in your audience.

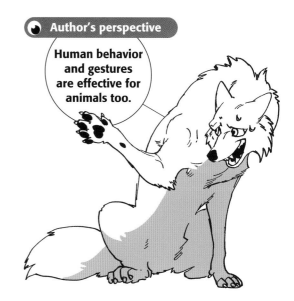

Author's perspective

Human behavior and gestures are effective for animals too.

Animation

Animation is basically a series of images strung together. So it's very time consuming to include gradients and textures to smoothly indicate contour and color changes.

If you can convey contours and depth with only lines and blocked-in color, you're off to a good start. It may look simple, but it's difficult to suggest three-dimensionality effectively using just lines without having an image of the underlying anatomical structure in mind.

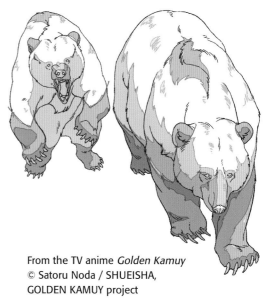

Screeching to a halt

Bear surprised by a snake

A bear from the other side of the woods.

From the TV anime *Golden Kamuy*
© Satoru Noda / SHUEISHA,
GOLDEN KAMUY project

Character Design for Games

Aggressive animals are often used in games as challenges for players to overcome.

That's why when one appears as an antagonist or "boss," I design the body to move differently than the animal that originally inspired the character does. The head tends to be positioned so the player can attack it and its stance is wide to present targets. Basic anatomical knowledge is needed to be able to pull this off.

Be aware that effective deformation is made possible through your knowledge of the animal's musculoskeletal structure coupled with your drawing aptitude.

Key Points for Basic Sketching

This method of basic sketching is essential for creating characters. Here, you'll learn how to perceive viewpoints different to your current set way of thinking and how to portray forms and movements in order to keep sketching enjoyable.

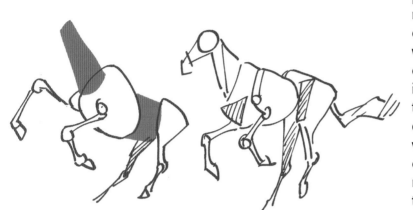

↑ The red sections exhibit lots of movement, while the other parts stay relatively still.

The aim of sketching isn't to draw a perfect picture. It's to increase how much detail there is in an object. If you consciously try to draw well, your brain will trick you into thinking you have to draw a certain way. So when sketching, it's important to just carefully observe the object and gain working knowledge of the key structural landmarks. With vertebrates, for example, the muscles depend on the bone structure. The muscles hold a lot of information, but try to be aware of the bone structure within (the areas that don't bend or stretch) as a reference point.

Sketching Forms

People are good at making things complicated. It's easy to only focus on the complex parts, and very quickly you'll find that you're starting to think sketching is hard work. While it may be a challenge to capture something in a simple way, if you can master this technique, you will be able to use it to gain insight into the bone structure that lies at the heart of the complexity.

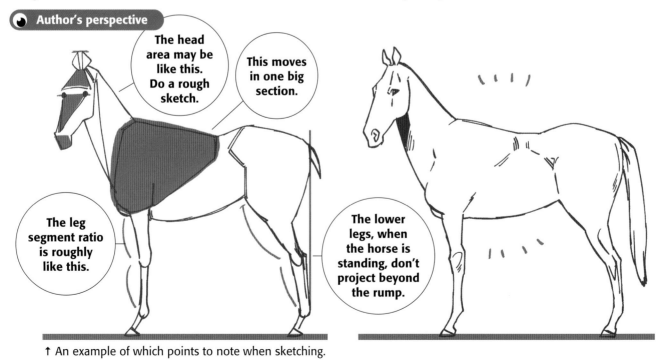

Author's perspective

The head area may be like this. Do a rough sketch.

This moves in one big section.

The leg segment ratio is roughly like this.

The lower legs, when the horse is standing, don't project beyond the rump.

↑ An example of which points to note when sketching.

Sketching Movement

Movement and form are connected, so start by alternating between creating sketches that depict different movements, followed by sketches that capture the form. If you keep alternating between these two types of sketches, you will increase the amount of detailed expression of the object you can capture a lot faster than by continuing to work on just one type. If you try pausing natural history documentaries, you'll be able to draw unusual animals too.

Identify Motifs That You Love and Keep on Drawing

There's little better than being recognized as someone who is always drawing a certain motif, and you agree that it's true.

I often draw horses. I like doing that, of course, but a horse has no fur or plumage to hide behind, so if part of the design isn't right, the whole balance of the drawing is off. This makes it a very challenging animal to draw, as you can't take any shortcuts. They're perfect for practice. I think it's fair to say that if you can draw a horse, you can draw any animal.

Drawing Real Animals

These are key points for creating characters from animals. In this section, I'll discuss what is needed to skillfully combine animal and human facial expressions. You will also learn how to practice the "Sumiyoshi way" to make the most of your passion for the characters.

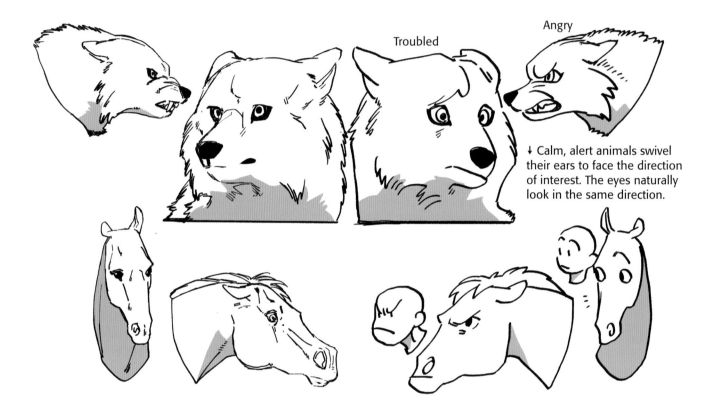

Troubled

Angry

↓ Calm, alert animals swivel their ears to face the direction of interest. The eyes naturally look in the same direction.

While real animals don't have human-like expressions, this doesn't mean they are expressionless. Each animal has its own unique expression. The most important telltales are the **ears**, then the **tail** and finally the **texture of the pelt**.

When you draw an animal, it's important to understand the musculoskeletal structure, but to be able to express it as a character, you need to take an interest in their movements and way of life, and observe those carefully.

Using a manga style to draw animals is an important element as it combines human expression with animal movements, appealing to people who have little interest in or knowledge of the original animals. To get this mix of animal and human essence, you need the knowledge and techniques to express the movement of human facial muscles and the ability to determine whether that matches the animal's emotional expressions or not. If you can do that, your range of expression for anthropomorphic characters with animal elements will quickly widen.

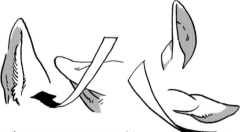

↑ The ears convey everything—nervousness, interest, fear and anger. For example, when an animal flattens their ears, they rotate down from the base, so be sure to study this response.

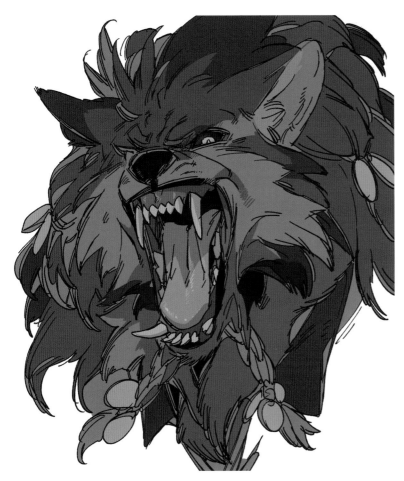

Do I Have to Learn the Basics Before I Can Draw Characters?

Not at all! Just get started!

It's really important that you do lots of sketches of your object to gain basic knowledge. But if you're wanting to start drawing characters before that, then of course start drawing.

Everything begins with practice.

Start by drawing and when you begin thinking *"I want to make it more attractive"* or *"what's happening with this part?"*—that's when you should shift to observing. That motivation is what leads to making practice fun.

By doing this, you can narrow down the points you want to focus on, advancing from vague sketches to knowing where to look because you want to draw a part or you want to observe a specific section so you can better understand it.

When practicing, consider how you sustain your work until you're consistently drawing skillfully and attractively. This is how you should practice. The key to improving is to have a concrete strategy. And it's so much better if you enjoy what you're doing, so that's why starting with objects you already want to draw is ideal.

Establish a Character's Personality, Starting with the Facial Expressions

Here, we look at the basics of facial expressions. We'll look further into how human emotions are exhibited on the face and how to have that correspond with animal facial expressions. By doing this, you can create a character's distinct personality.

Happy

The ears stand at attention and are swiveled in the direction of interest

Angry

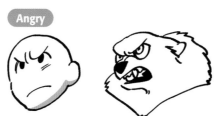

The form of the ears is couched within the silhouette of the body

Sad

The flattened ears form a silhouette

Alert

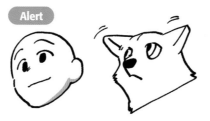

The ears move freely

Happiness, anger, sadness and pleasure—these are said to be the **basic emotions and expressions** that humans convey.

Once you have mastered drawing these, add the animal-like elements (ears and fur) as mentioned at the start of this chapter and, if you can give it an anthropomorphic style (like a character), it will establish an expressiveness that will appeal to those who view it.

Tips for Facial Expressions

These are lines added to the drawing, but the forms they are describing allow you to convey a sense of the thickness of the flesh. To create a more realistic look:

① **Observe when the eyebrows are lowered**
② **How are the eyelids covering the eyes?**
③ **What do the pupils look like?**
④ **When do the cheeks rise?**

It's good to try observing these and other points.

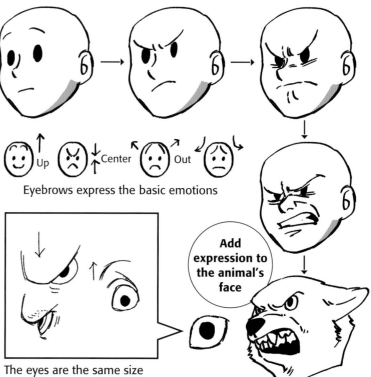

Eyebrows express the basic emotions

Add expression to the animal's face

The eyes are the same size for humans and animals

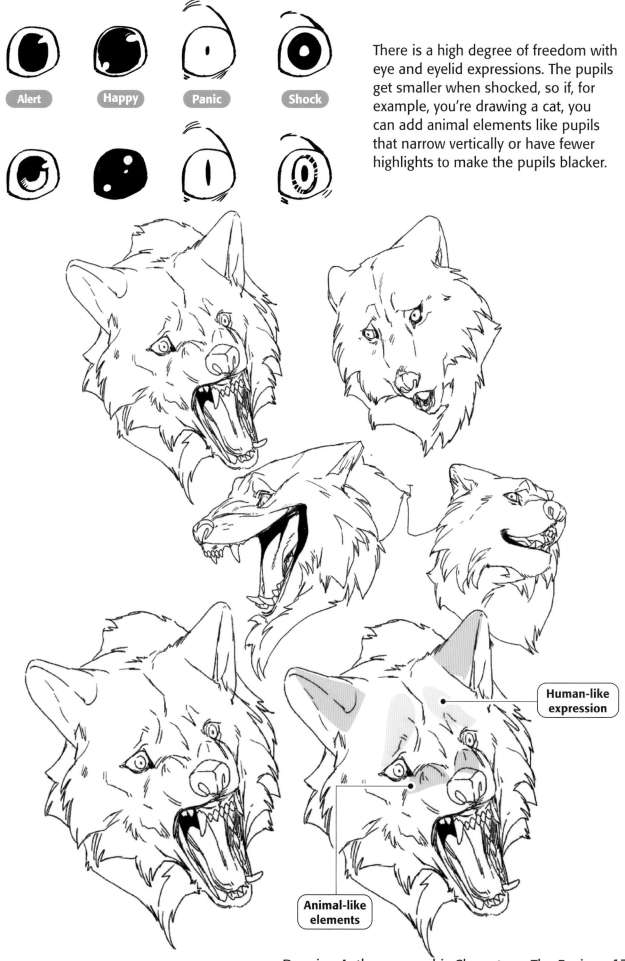

Alert **Happy** **Panic** **Shock**

There is a high degree of freedom with eye and eyelid expressions. The pupils get smaller when shocked, so if, for example, you're drawing a cat, you can add animal elements like pupils that narrow vertically or have fewer highlights to make the pupils blacker.

Human-like expression

Animal-like elements

Tips for Character Deformation

Let's learn the basics of deformation, which is used to change the shape of a real-life object. What do we need to make effective deformation possible?

Deformation is the intentional artistic alteration or abstraction of the shape of an object or material.

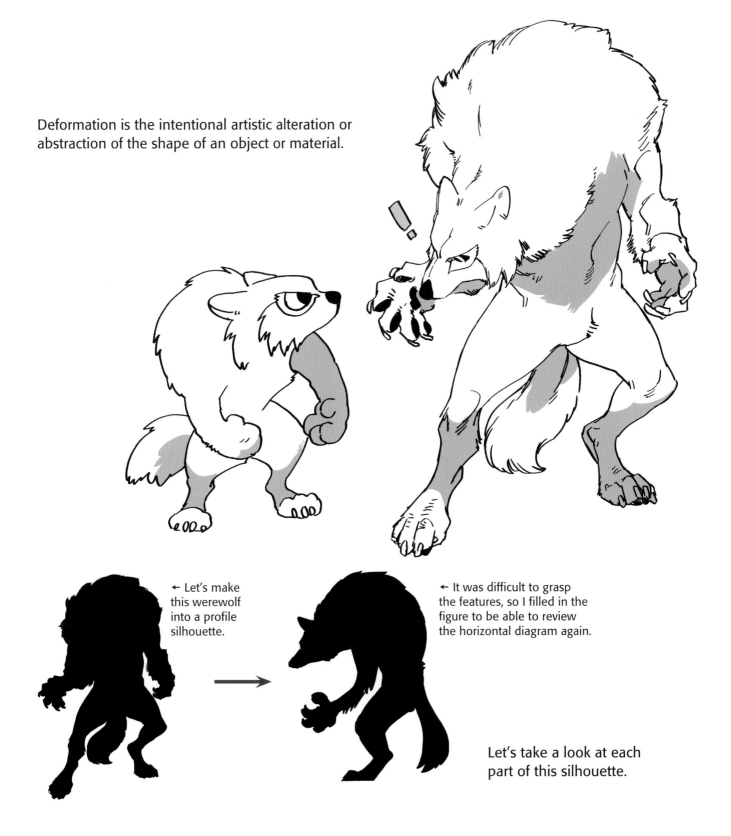

← Let's make this werewolf into a profile silhouette.

← It was difficult to grasp the features, so I filled in the figure to be able to review the horizontal diagram again.

Let's take a look at each part of this silhouette.

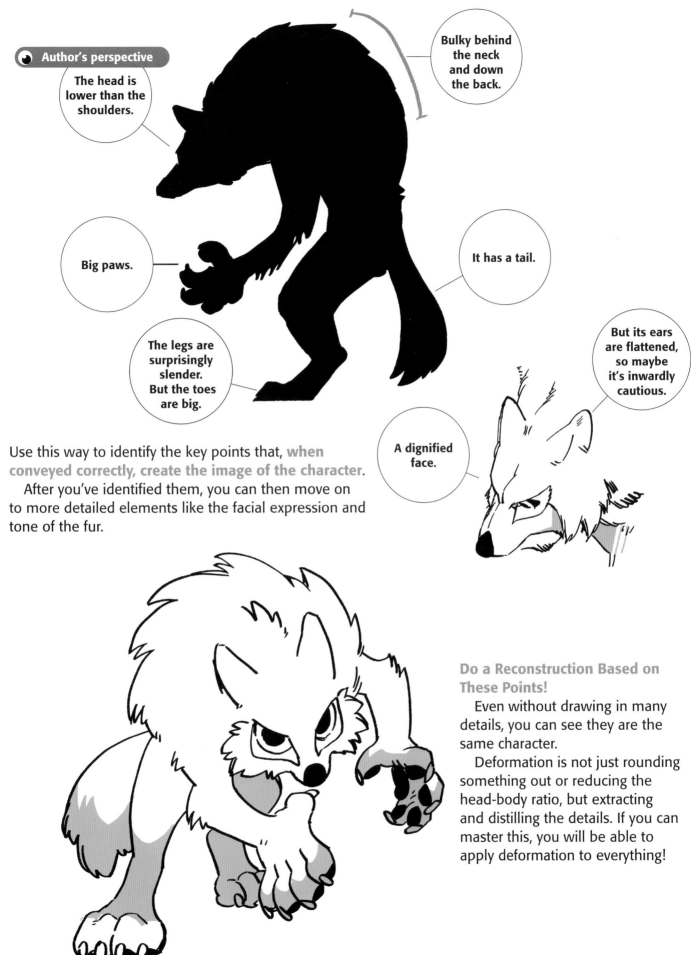

The head is lower than the shoulders.

Bulky behind the neck and down the back.

Big paws.

It has a tail.

The legs are surprisingly slender. But the toes are big.

But its ears are flattened, so maybe it's inwardly cautious.

A dignified face.

Use this way to identify the key points that, when conveyed correctly, create the image of the character.

After you've identified them, you can then move on to more detailed elements like the facial expression and tone of the fur.

Do a Reconstruction Based on These Points!

Even without drawing in many details, you can see they are the same character.

Deformation is not just rounding something out or reducing the head-body ratio, but extracting and distilling the details. If you can master this, you will be able to apply deformation to everything!

Drawing Anthropomorphic Characters—The Basics 15

Grasping the Basics of the Human Body

Let's take a look at the most basic human form. This is an essential element for creating characters, but it doesn't mean you have to draw a perfect skeletal structure. Here you'll learn the basic starting points.

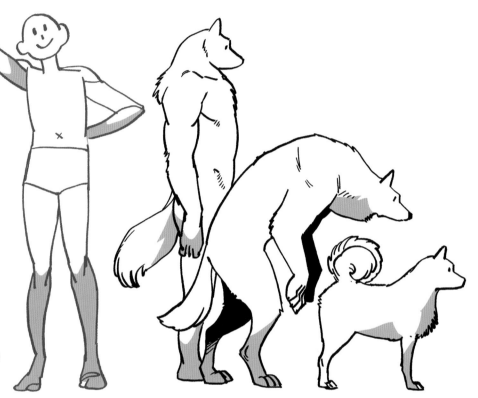

The last animal for which we will review the basics is the human. The largest difference between humans and other animals is the shape of the pelvis.

This is the part that makes us bipedal. But this is not the place for a dry primer about how to draw the human body. Simply speaking, if you just have a beast stand up, it will instantly be anthropomorphized.

For that reason, it's good to have an interest in the basic human movements and the range of motion for each joint.

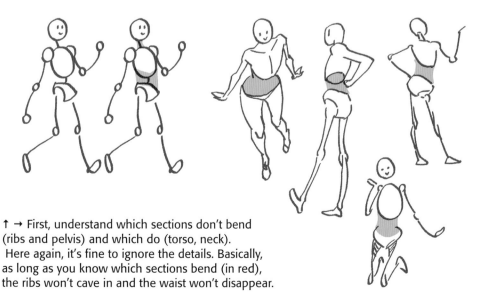

↑ → First, understand which sections don't bend (ribs and pelvis) and which do (torso, neck). Here again, it's fine to ignore the details. Basically, as long as you know which sections bend (in red), the ribs won't cave in and the waist won't disappear.

It's okay—humans are animals too! If you can view this the same way as for the horse sketch, you'll do fine. Let's look at this as if we're observing an animal. The human form is so familiar to us that we're more likely to look for mistakes and notice if something is off.

Knowing the Body Ratios is Key

Human movements are facilitated by joints. There are seven to be aware of—the shoulders, elbows, wrists, neck, hips, knees and ankles. If you memorize points in relation to other body parts, like the elbows are around the same height as the navel, you won't have to worry as much or get confused about the positioning and balance.

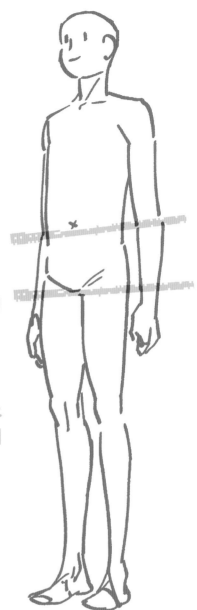

→ The elbows are level with the navel and the wrists are positioned at around the top of the thighs. The upper thighs and lower legs are about the same length, so the heels appear vertically below the position of the buttocks.

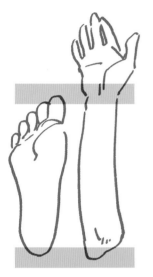

↑ The foot is about the same size as the length from the wrist to the elbow. If you forget your shoe size, you can use that to measure it.

↑ The neck circumference is about half that of the waist. When buying clothes, if you wrap the flattened waist band around your neck and it meets exactly, most likely it will fit your waist (if it's tight on the neck, then you'll probably find it a tight fit around the waist too).

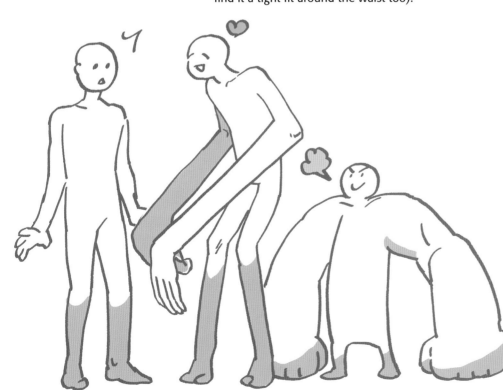

The reason why it's useful to know the basic body ratios is because you can create interesting forms just by slightly altering those common ratios. Every skeleton conveys a sense of the evolution of the organism. It's important to know the basic ratios and respect them while making deliberate alterations, otherwise your creatures could become unrealistic and bizarre.

Find Ways to Enjoy Observing and Drawing

Below are just a few of the things I keep in mind when sketching. As I draw I'm always thinking, "what's going on with this part?" I sketch while constantly asking myself, "is this really what it should be like?" I hope this is a useful reference for you.

I enjoy every aspect of this internal dialog. Finding an enjoyable way to observe and draw is very important.

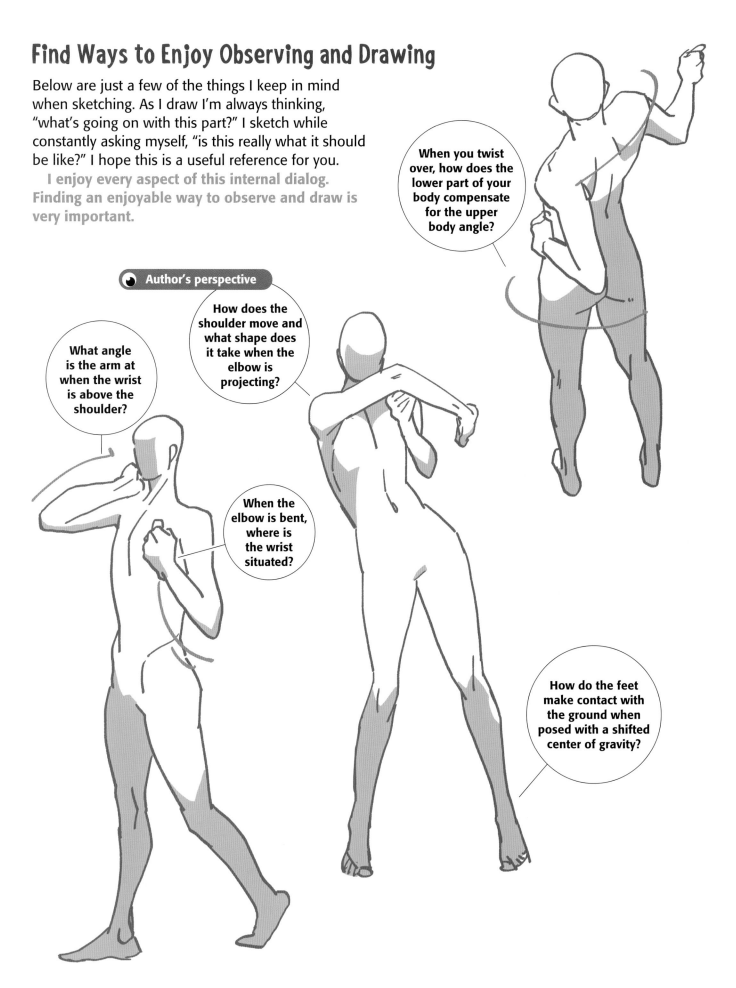

When you twist over, how does the lower part of your body compensate for the upper body angle?

Author's perspective

How does the shoulder move and what shape does it take when the elbow is projecting?

What angle is the arm at when the wrist is above the shoulder?

When the elbow is bent, where is the wrist situated?

How do the feet make contact with the ground when posed with a shifted center of gravity?

Useful Categorizations

These categorizations and interpretations are based on my style, and not all creators will categorize in this way. Anthropomorphism is a field with a wide range of expression. If you have a full understanding of your own interpretation, when someone comes to you with any kind of job request, you'll be better able to ask meaningful questions, leading to a more satisfying result.

1. Anthropomorphism (Ascribing human behaviors to non-humans)

This a method to ascribe human characteristics to non-human entities. Folktales with animal characters are good examples of this usage. Japanese folktales like "The Crab and the Monkey" exemplify this concept. Using the Western analogies of wise and foolish pigs, a bear cub with refined tastes or an insincere crocodile makes the stories entertaining and easy to understand, and you can express the roles, status and relationships at the same time. The following categorizations (2 through 6) are non-human entities that have been anthropomorphized in other ways.

2. Human-like Animals (Anthropomorphism that combines animal and human natures)

Almost of all examples are closer in nature and appearance to their animal species than they are to their human side. There are some that can communicate with humans, and these hybrids interact with humans of their own volition. This is a method that allows you to express entities that have a different culture or to whom human sensibilities don't seem to apply.

3. Furries (*Kemomimi*–non-human entities with human appearance and beast traits)

These are non-human entities in a form that feels familiar to many and makes them easy to be accepted by human characters who would not normally let different species into their community.

Although done in manga style, they are close in form to humans, so they can easily fit into human society and culture (and clothing), without the need to create a unique culture. This is also a method where you can express a sense of non-humanness through behavior and nature, and it also allows you, as an artist, to create broadly appealing characters.

4. Intelligent Monstrous Creatures (Including Yōkai)

This is anthropomorphism of natural phenomena and life forms (including monsters and yōkai) that have been created by humans. They are very different in appearance to humans and sometimes possess superior knowledge and intelligence, but they don't necessarily interact with humans. In my case, I use this categorization to draw types that are rather alien even if verbal communication with them is possible. On the other hand, if a creature has a human form, but has very otherworldly sensibilities and knowledge, they are also included in this categorization.

5. Kaijin (Monsters like *kaibutsu* and kaiju that resemble humans)

These are non-human entities that have an alien appearance, but have intelligence that is roughly equivalent to human intelligence. Even if they have immense power or a radically different form, if they exhibit sentience and the capacity for higher thought, they are including in this categorization. If they don't have intelligence, they are simply classified as a monster, while if they have more intelligence than humanly possible, they will be regarded as an intelligent monstrous creature (see above).

6. Monstrous Animals (Kaiju that are more beast-like)

These are entities that resemble *kaibutsu*, but express more wildness than intellect. This categorization is used when you want to portray a species that channels its intelligence toward satisfying its wild nature and that can cause an enormous amount of damage. Even if you give them a human form, they tend to be expressed as creatures that act instinctively. Zombies, vampires, and other undead entities are good alternative examples of this type.

These definitions evolve and overlap. They can't be definitive because the meanings will change as the terms become used in different ways, but I hope you find this useful as a reference for thinking about and drawing anthropomorphic characters.

Impression is the Key for Character Design

What do you want to convey when you draw animals like cats, dogs and horses? How do you develop a concept created from that feeling about a character? Knowing this process will help you advance as you develop original characters.

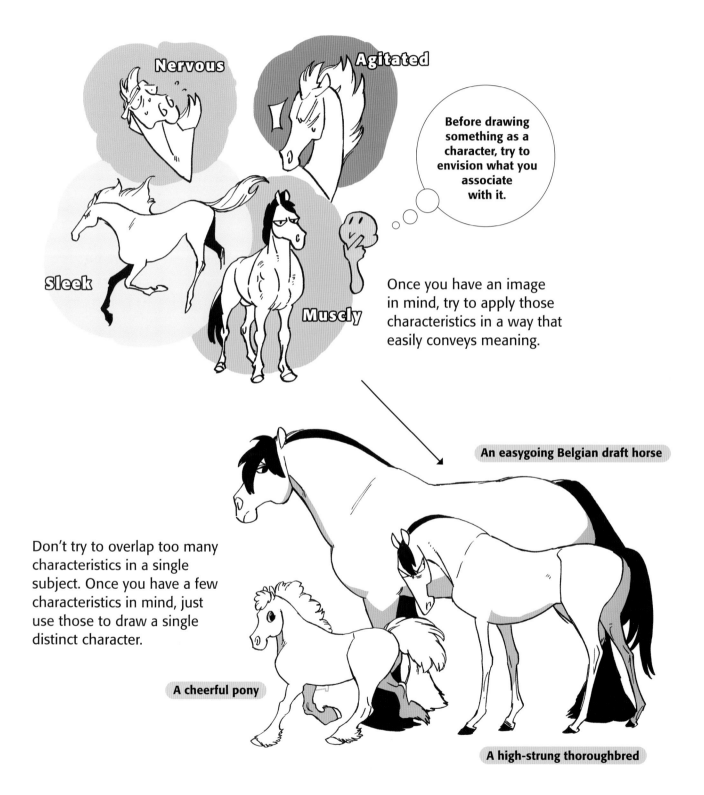

Nervous

Agitated

Sleek

Muscly

Before drawing something as a character, try to envision what you associate with it.

Once you have an image in mind, try to apply those characteristics in a way that easily conveys meaning.

An easygoing Belgian draft horse

Don't try to overlap too many characteristics in a single subject. Once you have a few characteristics in mind, just use those to draw a single distinct character.

A cheerful pony

A high-strung thoroughbred

An easygoing Belgian draft horse

This horse has legs twice as stout as a typical horse to give the impression of it being carefree and majestic. The heavy, droopy eyes also create a relaxed look.

By combining the characteristics of an animal with your impression, you can draw the animal as you perceive it and it will become a character. Even if the result is unrealistic, don't fail to pay heed to your general impressions!

A cheerful pony

The raised head, ambling gait, round eyes, soft flowing mane and the warm, lightly colored coat create an innocent impression. If you draw it much smaller than the other two horses, you can give the impression that it's unafraid to stand next to them.

A high-strung thoroughbred

Narrow eyes and extremely thin legs. This horse has a sharp, angular physique, and the emphasis of the strongly arcing neck gives the impression of a nervous temperament.

It has a kind of soft impression.

Warm, cold, hard...

People perceive most things not as hard facts, but as an impression. The reason I can't draw an object that I thought I knew well is because I don't have enough concrete understanding and am trying to draw only from my impression of it. When drawing something realistically, this is a hindrance. However, when drawing a character, a grasp of the general impression is very important.

Getting Ideas for Characters

Most games are designed in alignment with the client's conceptualization and based on the images and themes that they want. Here, we take a look behind the scenes of the creation of Tamamitsune in *Monster Hunter Generations*.

> ## Ideas are a game of association.

In creative endeavors, it is rare to nail down the final form on the first attempt and draw a definitive concept. Zeroing in on an approved form can often be difficult. Association exercises are useful in those situations. For example, in response to a request that "it should breathe fire, but live underwater," instead of worrying about not being able to use fire and water at the same time, try connecting the two together by thinking of underwater volcanoes and boiling seas to free yourself from assumptions and broaden your perspective.

A Typical Creative Process

1. Organize the Keywords

I designed Tamamitsune (Mizutsune) for *Monster Hunter Generations*. The initial instruction that the director came up with was:

- Draw a fox
- Give it water attributes
- Make it graceful

That was it.

A ghost-like form? I can't get it to feel real...

2. Select the Monster Elements

The keyword "fox" seemed paramount and, as members of the monster design team, we based our ideas around this keyword. We struggled to imagine how to incorporate water elements and transform the creature into a monster.

Do "water attributes" for mammals mean slobber? It'll look horrible...

3. From Ideas to Elements

What I did was to associate the keywords that I came up with to other things. I expanded my image out from "fox," "water," and "beautiful," but ideas that come up first can get in the way, so I tabled them for a while.

What's the essence of a fox?

4. Combining Attributes to Create a Form

I re-examined the words I'd parsed out and found hints I could possibly use, like moray eels with yellow mouths and orchid petals that resemble the silhouette of a fox's face, to construct an image.

Even if you don't draw a fox outright, it's fine to combine the elements to form the outline of a "fox."

Water attributes can be expressed naturally with fish and you can use a body color that is more vivid than would be possible for mammals. For elements that look like fur, I added fins and spines like those of porcupinefish and luna lionfish!

Fox associations
Mysterious → entrancing → beautiful → Japanese style

Mysterious associations
Yōkai; purple; moray eel; deep-sea creature

Entrancing associations
Glistening; swaying; pale

Beautiful associations
**Flowers; goldfish
...and more**

5. Completion

This was the process I used to create the monster Tamamitsune. This was the same process as for the other monsters too, and almost enough to give me an ulcer, so please take a look (ha, ha)!

Design drawings for Tamamitsune

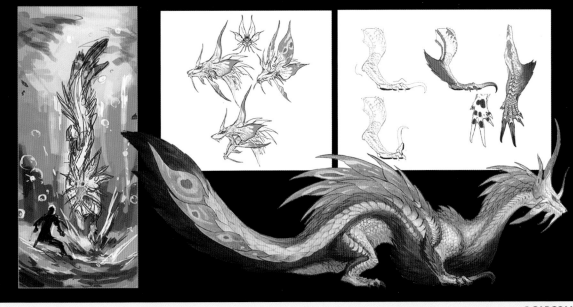

©CAPCOM

What Exactly is Anthropomorphism?

So far, we've been thinking about humans and animals, but now we'll finally look at the existence of anthropomorphism. You will learn what kind of entity they are, how to get the balance between human and beast, and specific ways to produce them.

(L→R) Ajai (original work from the project *Shinwa no Kemono*), Naptam (*Toruso no Bokura* [Libre]), Matsukaze (*Jinba* [East Press])

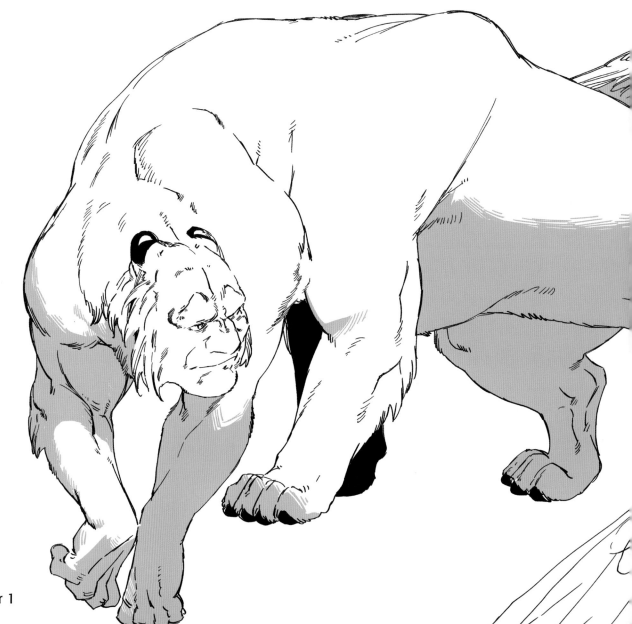

Non-Human Forms of Life—Separate Entities with Different Skeletal Structures, Muscles and Lifespans

To sum them up, these are sentient entities that are "**not human**." It's very simple. But even so, they are not just intelligent animals. They are inexplicable entities that can understand human language. This makes them very nuanced and complex. If they are other than human, what makes them different? And if they are different, which parts? Their forms? Their gestures? Their ways of life? Where do you draw the line for what is "different enough?"

If you want to draw something divergent, you need to know what remains universal. You can inject a lot of variety by being interested in what makes sense for hybrid biologically. You are drawing something with a unique fantasy lifestyle. I think of character design as "**personality design**."

Once you start thinking this way, there is no end to what you can come up with. This is how I design innumerable forms. Drawing non-human entities enables you to draw more characters. You can immerse yourself in an unknown world. It's a wonderful method.

And that's why drawing characters that are greater than the sum of their parts increases your degree of artistic freedom.

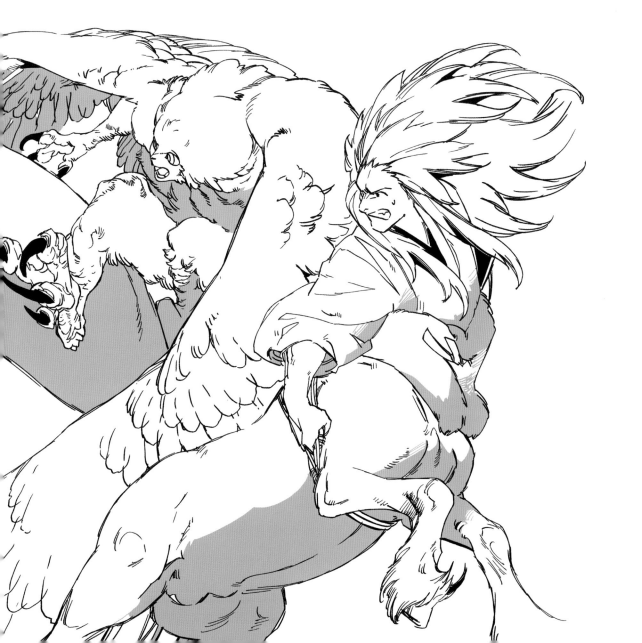

More Human or More Animal? Balancing the Elements

There are various ways to express anthropomorphism. It varies greatly, depending on whether the character is more human or more animal-like. The more human characteristics there are, the more communication is possible because you'll be able to incorporate human body language.

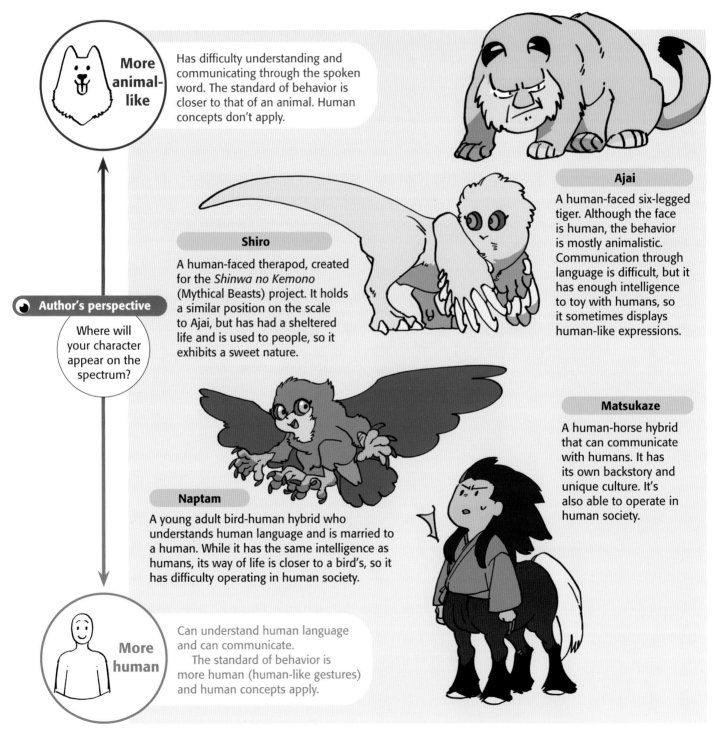

More animal-like

Has difficulty understanding and communicating through the spoken word. The standard of behavior is closer to that of an animal. Human concepts don't apply.

Ajai

A human-faced six-legged tiger. Although the face is human, the behavior is mostly animalistic. Communication through language is difficult, but it has enough intelligence to toy with humans, so it sometimes displays human-like expressions.

Shiro

A human-faced therapod, created for the *Shinwa no Kemono* (Mythical Beasts) project. It holds a similar position on the scale to Ajai, but has had a sheltered life and is used to people, so it exhibits a sweet nature.

Matsukaze

A human-horse hybrid that can communicate with humans. It has its own backstory and unique culture. It's also able to operate in human society.

Naptam

A young adult bird-human hybrid who understands human language and is married to a human. While it has the same intelligence as humans, its way of life is closer to a bird's, so it has difficulty operating in human society.

Author's perspective

Where will your character appear on the spectrum?

More human

Can understand human language and can communicate.
The standard of behavior is more human (human-like gestures) and human concepts apply.

If you use the chart on the left, you can create these kinds of categorization. Here, I've used canine-based characters to demonstrate.

Ruban

Ruban is the most beast-like. The face has a generally human-like skeletal structure, but its body has a forward-leaning posture and it doesn't project the impression of being able to communicate verbally.

Cory

Cory looks like an animal, but the posture and expression of the hands are close to human. Adding clothes instantly increases the impression that it can communicate verbally.

\Tut!/

Simplified sketch

Nero

Nero is the most human-like and recognizable as *kemomimi*. When drawing non-human creatures, it's helpful to think about how much the character will be able to fit into human society.

Adding Movement to Your Character

Once you've created a certain amount of expression for your character, it's time to add movement. It can be when shopping or talking with friends, but why not try creating a short manga to do some world building?

Add facial expressions to explore the character more deeply. When you do this, think about when and why your character cries, gets angry or laughs rather than just rehearsing stock emotions. It's profitable to draw while you explore those ideas. That way, you'll be able to add more depth to facial expressions. You'll also get to experience the joy of discovery as you add more meaningful expressions. To gain a better understanding of your character, consider what they think about and how they feel and react. You'll be able to get a grasp on your character's situation and status, and the world they inhabit.

Try deformation

Create a backstory like "getting angry when their friend is hurt" to help you discover more meaningful facial expressions.

◑ Author's perspective

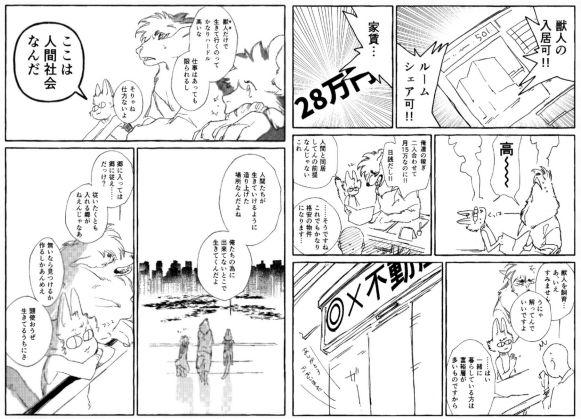

↑ The expressions used in manga are also suitable for exploring the world that the character is situated in, along with the character itself.

Using Posture to Convey More Human or Beast-like Traits

The silhouette formed by the pose can convey an instant understanding of whether the character is more beast-like or human-like.

The posture, head position, and center of gravity are key. Even if there is no beast in the design, you can adjust the beast-like traits just by using this combination.

Although its appearance has a high proportion of animal-like features, it is standing upright like a human. The center of gravity is the same as that for a human, so it seems like it's possible to communicate with it verbally. If you reverse this impression, you can use facial expressions and gestures to create a cool animal-like appearance in which verbal communication looks impossible.

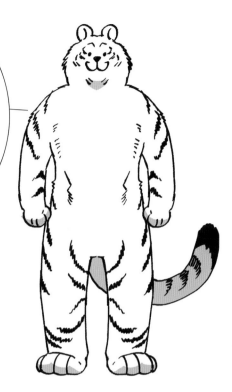

The elements are human, but its center of gravity is pitched forward as if it will drop onto all fours at any moment. It has a beast-like look, with a raised back as if poised for attack.

Humans have a center of gravity directly under the crown of the head. Whatever the motif, if you want to create an animal-like look, shift the center of gravity (position of head) forward and you can achieve this.

Even from a front-on view, if you shift the head down to lower the center of gravity and give the body more of an S-shaped curve than a typical human, it will look beast-like.

Rather than worrying about whether the form is good or bad, think about what you want to express with the character. Be aware of what you need to do to be able to accomplish that.

A Unique Character Created with Keywords and Associations

When I'm creating a character, an important task for me is to consider how many associations I can make from dozens or even several hundred keywords. Natural science, biomechanics, stratigraphy, human history, natural history—3.6 billion years of historical information held by the Earth itself—those are keywords for me.

But, as with sketching, you don't have to overthink things. How do you simplify the thought process? Out of the huge amount of information, rethink and reconstruct the keywords that will form your design framework and from those same keywords, you will be able to draw 10 or even 100 different characters.

Drawing characters brings me joy. So I want to spend my life doing everything I can to draw as many unique characters as possible.

That's the same feeling some people (maybe you!) share as they draw each character. I hope that you can learn that by looking at these materials, increasing the level of detail, and coming into contact with, seeing and knowing new things, you can find the joy of meeting more new characters than you will ever be able to draw.

Anthropomorphized Mammals

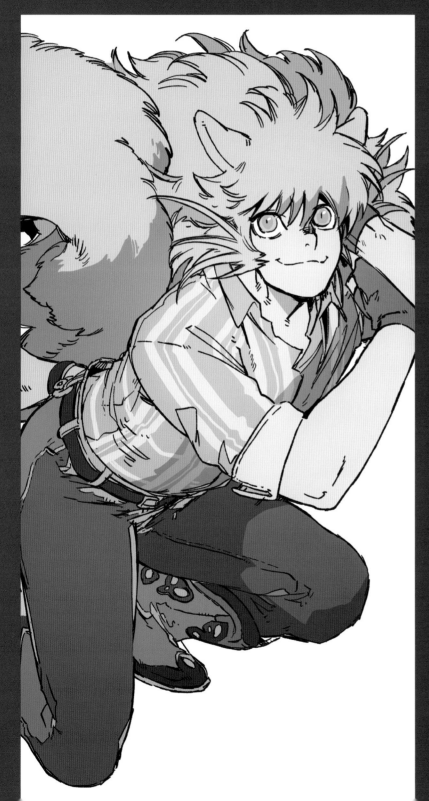

In this chapter, we'll look at anthropomorphized mammals. How do you capture the characteristics of dogs and cats that are so familiar to us, and what kind of process should you use to incorporate them into concrete forms and movements? I will explain various levels of anthropomorphism (refer to page 26), including *kemomimi*, using past examples of my work.

Designing a Cat Character—Part I
(Drawing Furries)

Here, I'll design a *kemomimi* (furry) based on a cat that has a strong emphasis on human features. How do we go about introducing elements associated with the features and keywords to make a great character? Using your imagination and knowledge will let you create much richer expressions.

This is a Maine Coon (cat) shooter. I associated the keywords "quick," "agile," and "hunter" with cats and as the Maine Coon is an American breed of cat, I came up with the following elements.

1. Hunter → Marksman
2. Marksman + United States → Cowboy

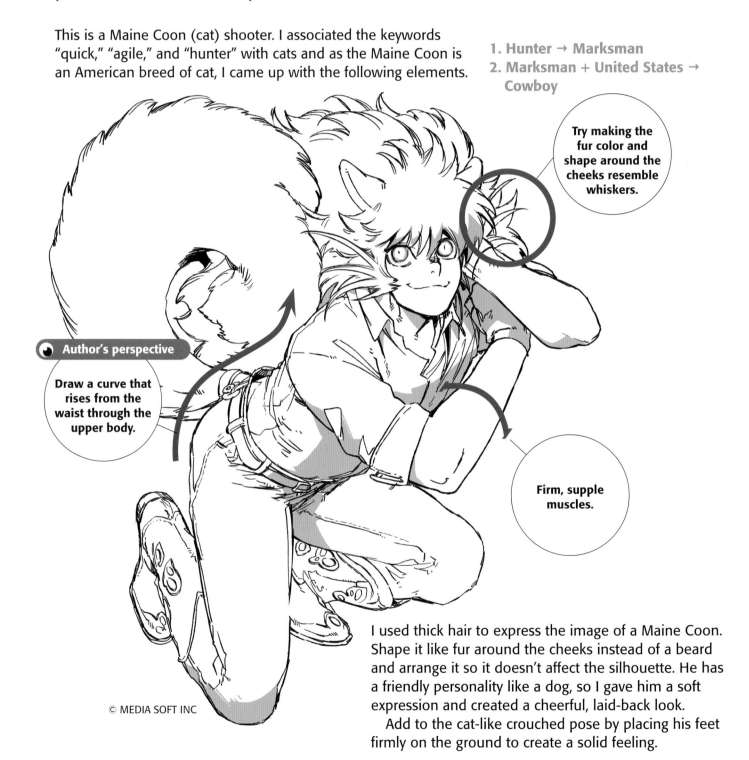

Try making the fur color and shape around the cheeks resemble whiskers.

Author's perspective

Draw a curve that rises from the waist through the upper body.

Firm, supple muscles.

© MEDIA SOFT INC

I used thick hair to express the image of a Maine Coon. Shape it like fur around the cheeks instead of a beard and arrange it so it doesn't affect the silhouette. He has a friendly personality like a dog, so I gave him a soft expression and created a cheerful, laid-back look.

Add to the cat-like crouched pose by placing his feet firmly on the ground to create a solid feeling.

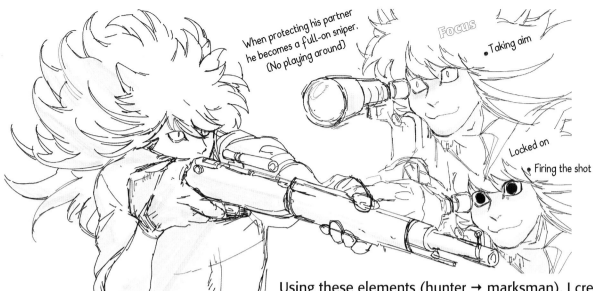

Using these elements (hunter → marksman), I created a sniper who supports his partner from afar. The more laid-back the character usually appears creates sharper contrast for when he springs into action as a hunter.

The accent color is the blue of his eyes. If only the eyes are blue, they'll seem out of place, so I created a cohesive look by adding turquoise as decoration on the boots.

Tips for Color Schemes

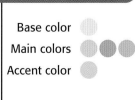

Base color
Main colors
Accent color

You can express the personality and atmosphere of a character by using color too. The colors are roughly divided into a base color that takes up a large area and creates an impression of the character's look; the main color pulls everything together; and the accent color that is only used in small areas, but is bright and meant to catch your eye. Selecting a main color that has low saturation is more effective.

Designing Dog Characters
(Drawing Furries)

This is a *kemomimi* design based on a dog rather than a cat. When you're creating partner duos, you want the individuality of each character to stand out when they're portrayed together. Think about attractive color schemes that create synergy too.

This is the Maine Coon shooter's partner. To highlight the difference between the two characters, I thought about which dog breed to use based on contrasting elements to the cat.

1. Large build → small build
2. Light tones → dark tones
3. Long-distance sniper → close proximity shooter

As a result, I chose the small, loyal Miniature Pinscher and drew him as a tough, agile, fast shooter.

I made sure to draw the silhouette with angled lines to give a contrasting impression to that of the cat. If you are drawing a *kemomimi* that doesn't have four ears (one pair human and one pair animal), you can use side burns or loose hanging hair. In addition, with this type of muscular character, you can express the thickness of the body by adding wrinkles to the clothes where there are joints or the muscles are taut.

Author's perspective

The curve from the waist up to the head is not as prominent, to differentiate it from the Maine Coon.

The short hair is key here to transforming a short-haired Miniature Pinscher into a *kemomimi*.

Pay attention to the outline of the clothes when expressing the muscles and body thickness.

Compact

If your character is an adult of small build, widen their shoulders and reduce the overall ratio to create a better balance. Be aware of where you place the facial features too. You can also express the size of the body by juxtaposing it with the items your character will carry.

© MEDIA SOFT INC

Base color

Main color

Accent color

The color scheme is the opposite of that for the cat. I used red for the base as it gives a strong impression, as well as being the color of danger, and for the main color I used a calm gray to match the small adult-like character. For the scarf, I used olive green as an accent color to express softness and gentleness.

If you have knowledge of colors, you can create interesting color schemes that take advantage of the psychological effects that colors have on people. In addition, when you're drawing a lot of people, think about colors that will make the main character stand out.

Include indications of a Miniature Pinscher's loyalty in what he wears, such as a dead master's dog tag.

> For the taut dog muscles, draw raised blood vessels and tendons, and add sharp lines to emphasize the angularity of the arms.

The difference between the Miniature Pinscher's arm (top) and the Maine Coon's arm.

> Cats are supple, with sleek muscles, so be aware of the longer ratios and rounded lines.

There is freedom in drawing. That's why you need to identify features that make you think "this is attractive in this character" and then remain cognizant of that while you draw, otherwise you'll start to shift away from them. While you're searching for a way to convey these points, it's easy to lose sight of them, so while exploring your characters, always seek out their strongest features.

Designing a Cat Character—Part II (Drawing Human-like Creatures)

This is a character partway between a *kemomimi* and a non-human entity. The process is the same as for *kemomimi*, where you use your imagination to associate keywords that are expressed in your drawing. It's good to emphasize the elements that can convey the features.

Author's perspective

Even without hair, you can express a silhouette that flows by taking advantage of fabric and accessories.

This is a Siamese cat thief. I used the keywords "quick" and "supple" associated with cats to envision the following elements.

And because Siamese cats are originally from Thailand, I added Thai elements to the character's clothes and look.

• Quick + supple → Thief

It's fun to think about whether to include a tail and how to have it emerging from the costume.

The only material for the costume is fabric, to create a light impression (see the facing page for reference)—and I wanted to convey that the character has martial arts skills, so I made the weapons stand out.

The clearer the image you have beforehand, the less you'll need to worry about expressing the items.

When you draw a character, be aware of poses and compositions that clearly show items and parts that are important to the character. Doing so will make it easier for your audience to feel the character's presence. Having a strong central image makes it much easier to draw detailed items like weapons and decorations, and it facilitates depicting the character's way of life and way of moving.

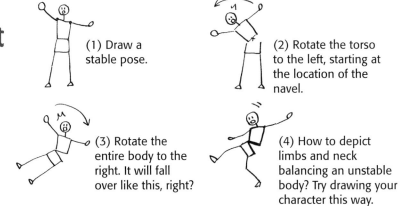

As this is a thief, I added an accessory so they can hide their face easily.

The character is wearing small pieces of cloth to show its suppleness and the unique coloration of the Siamese cat forearms and face resemble gauntlets and a mask. By hiding the face, the impressive eyes of the character can be made to look even more prominent and, as they are a human-like beast, emotions can be expressed with the ears.

Tips for S-shaped Curves

Movement is characterized by the S-shaped curve mechanism, mentioned previously, moving in reverse. By shifting the head significantly away from where the most weight is applied, you can express lively movement.

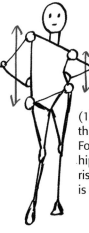

(1) Think about a structure that creates body balance. For example, when the left hip rises, the right shoulder rises and the stretched torso is supported by the left leg.

(2) If you stay aware of the front and back of the body, you can express the twist and depth on both sides, as well as up and down. In order for the body to balance, the head moves to align with the center of gravity.

(3) The S-shaped curve becomes stronger as more force is applied, regardless of the direction.

Overcoming Instability— Master Expressing Movement

People who can't draw movement well are often not good at depicting instability. They tend to want to make the character stable. If that's the case, first shift the position so the character is unstable and it will be easier to draw. When you're having difficulty understanding, try making the same pose with your own body.

(1) Draw a stable pose.

(2) Rotate the torso to the left, starting at the location of the navel.

(3) Rotate the entire body to the right. It will fall over like this, right?

(4) How to depict limbs and neck balancing an unstable body? Try drawing your character this way.

Designing Werewolf Characters
(Drawing Human-like Creatures)

This is a wolf character that is quite human-like for a beast. Let's think about the design in line with the backstory, including how it is different in appearance, impression and presence to the Siamese cat thief.

This is the werewolf who appears in my manga *MADK*. As the feline human-like beast was depicted with dynamism, I gave this character the sense of a dignified valet. It's positioned as a sentient werewolf, so I tried to make it appear as a human-like beast that can communicate verbally.

I gave it a well-groomed appearance with neat hair and a straight, bipedal gait to reduce the impression of ferocity. Moreover, I deliberately removed the tail, an essential element of *kemomimi*, to make it more human-looking and emphasize the uniquely contrasting quality.

← When drawing a large face and adding a body, if you draw it standing at an angle viewed from above, it will fit more easily in the frame.

© Printemps Shuppan

I decided not to add much deformation to the head, so I did a lot of wolf head sketches that would form the basis of the character. I studied the neck area in particular, for example. I slightly lengthened the neck bones so that the neck naturally connected from the animal head shape to the human neck line. I used the morphology of birds as a reference.

The two wolf-humans below are "mob" characters from *MADK*. While "mob" may be a familiar synonym for "gang," in manga it also refers to entities that are living rooted in that world and reflect the world at a single glance. So, I put a lot of thought into mob characters. With that, if you slightly exaggerate their individuality and unique characteristics, the world building will be naturally apparent. For drawings, it's really important to focus on having silhouettes that accentuate the look of the characters, rather than having them look accurate.

Neck shrinks to this point

Neck shrinks to this point

Twists round

stretch

Shrinks more

Fluff up

↓ It's useful to draw juxtaposed humans because this is an easy way to establish scale.

Baggy pants, so they won't rip completely apart (for modesty!)

Hair stands on end when angry, increasing perceived size

↑ When provoked, the fur bristles, making it appear much thicker than usual.

Designing a Fox Character
(Expressing Anthropomorphism)

The way to create a non-human character is to keep in mind the characteristics of the animal the character is based on and incorporate them into the design. Here you'll learn the key points to expressing states and qualities, including humanness, which is essential for anthropomorphism.

For a beast-like creature with no human features apparent, you can still create the impression that a character is a werewolf hybrid. This character has fox-like attributes, but doesn't appear in the real form of a fox. In other words, as long as the creature has a "long, slender muzzle," "pointed ears" and a "bushy tail," it can give a fox-like impression even if its proportions are extended or reduced. The shape of the paws is important too. Even if the rest of the body is animal-like, if you make the paws human-like, that alone creates an uncanny look. The thumb is the most distinctive part of the human hand, and its presence can add to the human-like appearance.

↑ Simplify complex shapes. If you draw a line following along the top and bottom of the neck, you can more easily understand how to draw its twist.

↑ The Japanese fox mask exhibits major deformation, but is still recognizable as a fox, despite not closely resembling a real one. Folk crafts can be very inspiring for creativity.

Tips on Creating Color Variation

I tried creating color scheme variations based on the keyword "fox." You can see how the impression and presence changes immediately through the use of different color schemes.

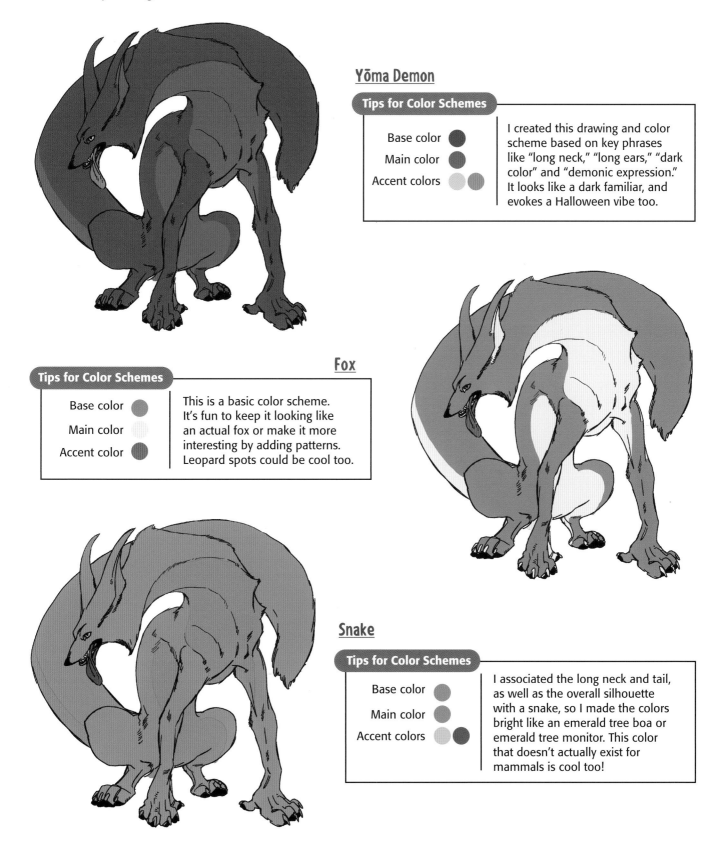

Yōma Demon

Tips for Color Schemes

Base color

Main color

Accent colors

I created this drawing and color scheme based on key phrases like "long neck," "long ears," "dark color" and "demonic expression." It looks like a dark familiar, and evokes a Halloween vibe too.

Fox

Tips for Color Schemes

Base color

Main color

Accent color

This is a basic color scheme. It's fun to keep it looking like an actual fox or make it more interesting by adding patterns. Leopard spots could be cool too.

Snake

Tips for Color Schemes

Base color

Main color

Accent colors

I associated the long neck and tail, as well as the overall silhouette with a snake, so I made the colors bright like an emerald tree boa or emerald tree monitor. This color that doesn't actually exist for mammals is cool too!

Designing a Centaur Character
(My Process for the Manga *Jinba*)

Pictured below are examples from my manga *Jinba*, featuring my favorite motif—the horse. This section's summary will be based on the characters from this work, and I'll introduce the process of using actual horse breeds to create characters, and how I link their unique characteristics to their habitat.

The inspiration for these characters were native horses that worked in Japan. Having been involved in the development of my homeland, where did they go? While researching them, I did a deep dive into the history of Japanese horses. That's what I wanted to draw in my own way. But horses alone will mainly appeal to horse aficionados.

 Was it possible to use a more eye-catching motif that could capture the imagination of a wider audience? Was there a form that could be used as a fantasy story element to convey my narrative to people, rather than just depicting dry historical facts? It was from these questions that I arrived at the centaur, half-human and half-horse, which is well-known even to those who aren't familiar with mythology. I wondered if it was possible to combine this concept with a Japanese armored warrior to create an extraordinary Japanese centaur.

 That was how *Jinba* originated. The main characters are Kohibari, a plains-dwelling centaur, and the tough, brave Matsukaze. Kohibari is based on an Arabian draft horse, so even though it's not good at twisting its body, it's flexible and can jump like a coiled spring. Matsukaze, meanwhile, is based on the Kandachime, a wild horse breed that lives in the northernmost part of Japan's main island Honshu. I did consider the Kiso horse at first, which is also from Japan and is tough and steady. It has a strong, compact body with dense, diminutive hooves, but because it has a small physique, it's difficult for it to project the power needed for the story.

 This was the breed I landed on after struggling with this: the Banei, a Japanese draft horse used for racing, which is very close to Breton and Belgian breeds. So I gave Matsukaze a powerful silhouette and robust characteristics.

→ Kohibari is a grassland centaur. His fine, slender legs are poorly suited for the mountains, but he runs swiftly on level ground.

Jinba Volumes 1–6 (East Press)

← Matsukaze is a brave mountain centaur. He's tough, with sturdy legs and strong hooves that can handle even steep mountain paths and rocky terrain.

→ The Kiso horse and Hokkaido horse, which have adapted to the Japanese climate. The more you learn about Japanese horses, the more attractive they become.

← Many of the large horses in Japan have a Breton pedigree.

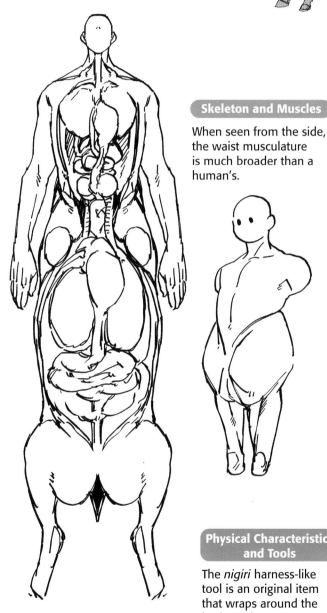

Skeleton and Muscles

When seen from the side, the waist musculature is much broader than a human's.

Making a Fantasy Creature a Living Thing

Fantasy creatures can be given a greater sense of reality by creating their history, culture and social background that goes beyond just describing their physiology, and this raises them to a new level of plausibility.

When I drew the centaurs, I did think about the skeletal structure and the placement of the internal organs too. With the skeleton, I focused on the position of the hips of a human. If the human portion is too high above the horse's shoulder blades, it might hurt the lower back, so I nestled it between the shoulder blades. As it's so stoutly anchored from the side to back, the waist area is significantly broader than a human's. I explored this part thoroughly to be able to convey a sense of stability when depicting a running figure.

While the primary organs are located within the horse body, the accessory organs are in the human body. They pump blood from the horse body to the human one, filter toxins that are poisonous to animals and causes indigestion in humans, break down food and send nutrients to the horse body. These are just some of the many considerations that aren't mentioned in the story.

The *nigiri* harness attached to the body is an important item in *Jinba*, which takes advantage of the characteristics of this centaur hybrid.

I used these types of original tools to convey the centaur's level of cultural development.

Physical Characteristics and Tools

The *nigiri* harness-like tool is an original item that wraps around the body so the centaur can act as its own jockey.

Internal Organs

The digestive organs are dispersed between the two bodies. The intestines and torso are shorter than that of a horse. This individual can maneuver well despite their large build.

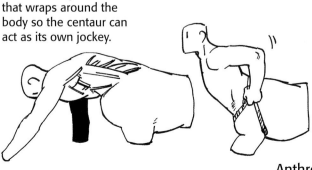

Establishing the Anthropomorphic Character's Lifestyle and Culture
(My Process for the Manga *Jinba*)

Your created character should have a world and society in which it lives. Think about the history and culture too and make notes of the ideas you come up with. If you look at this page, you'll see that in order to create lively depictions you need to do enough preparation.

When imagining tools, it's important to consider the species' situation and the strength of its way of life, as well as the overall condition of the natural environment. I'll carry on from there to think about how they adapted and evolved, what tools were needed, how they were created and how they became rooted in society. While it's all imagined, I considered the level of culture these centaurs had with their thick skin, resistance to the cold and robust digestion. For example, what type and thickness of material would they wear? I thought up a whole range of essential tools to go with this lifestyle too. I referred to tools that exist in real life, such as for camping and woodcraft, as well as looked at the way of life of humans in the Stone Age.

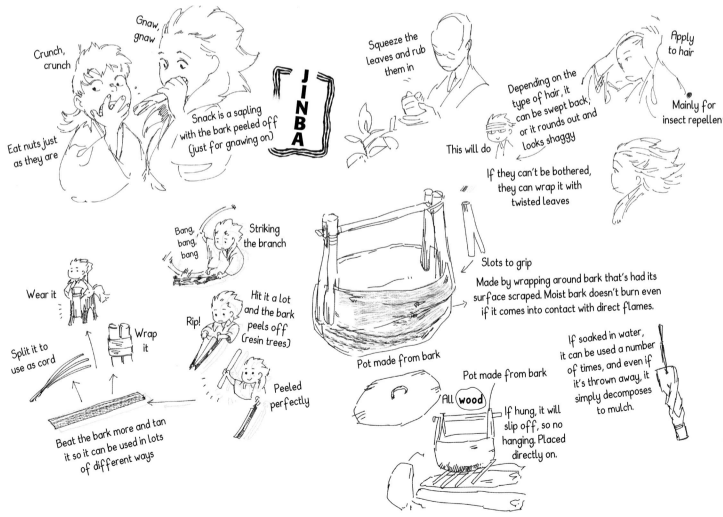

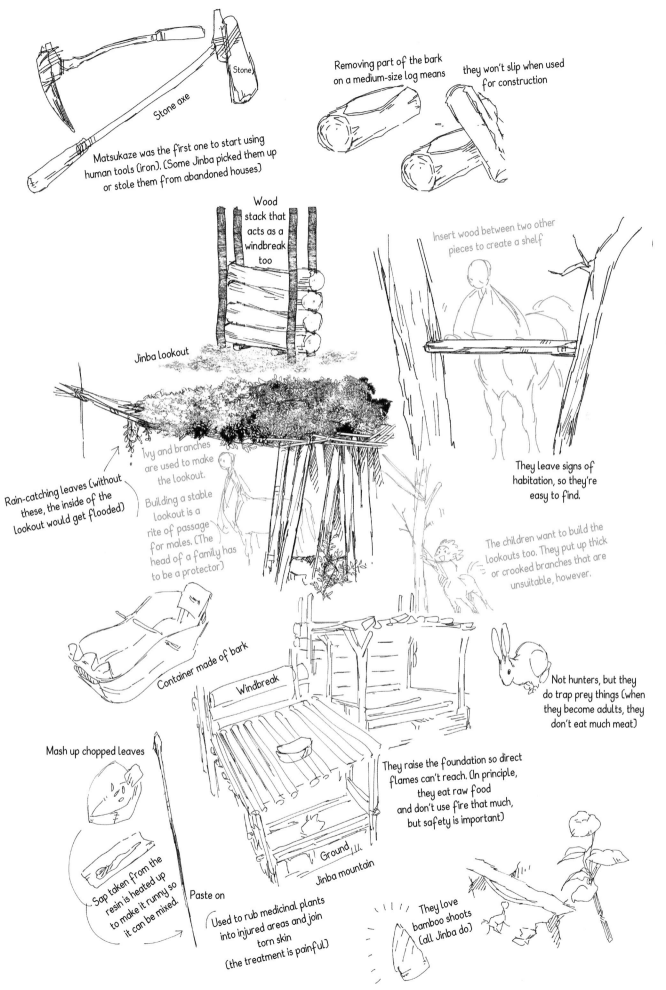

Stone axe

Stone

Matsukaze was the first one to start using human tools (iron). (Some Jinba picked them up or stole them from abandoned houses)

Removing part of the bark on a medium-size log means they won't slip when used for construction

Wood stack that acts as a windbreak too

Insert wood between two other pieces to create a shelf

Jinba lookout

They leave signs of habitation, so they're easy to find.

Rain-catching leaves (without these, the inside of the lookout would get flooded)

Ivy and branches are used to make the lookout.

Building a stable lookout is a rite of passage for males. (The head of a family has to be a protector)

The children want to build the lookouts too. They put up thick or crooked branches that are unsuitable, however.

Container made of bark

Windbreak

Not hunters, but they do trap prey things (when they become adults, they don't eat much meat)

Mash up chopped leaves

They raise the foundation so direct flames can't reach. (In principle, they eat raw food and don't use fire that much, but safety is important)

Sap taken from the resin is heated up to make it runny so it can be mixed.

Paste on

Ground

Jinba mountain

Used to rub medicinal plants into injured areas and join torn skin (the treatment is painful)

They love bamboo shoots (all Jinba do)

Fictional Animals Based on Animal Characteristics
(My Process for the Monster Ajai)

If you understand the skeletal structure and elements of an animal, you can make your character more realistic and believable, even when it's fictional. Here, we'll look at the design process, using the monster Ajai as the example.

To begin with, I sketched a lot of horses in order to create the centaur that was the main character for *Jinba*, and it was through doing this that I became convinced it was the ultimate hybrid. That led me to the question of what would happen if I drew a human hybrid based on a stealthy feline, a strong contrast to a stately centaur. The design I tried to put into that form was the monster Ajai.

Be sure to make notes of all the research information you collect, even if you don't actually use it in the manga. When you're not drawing, imagine what the character is doing or what they have been doing as this will be very useful for drawing them in natural poses in casual scenes.

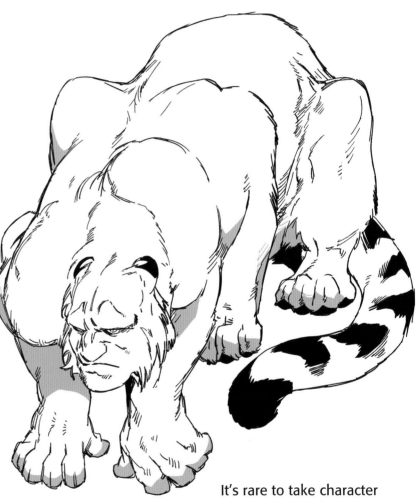

It's rare to take character design alone this far, but when drawing a character for a manga or story, before I start the serialization, I research, draw, review, correct, research... on and on like this. This is an important and lengthy process that should not be avoided, so I recommend you give it adequate time.

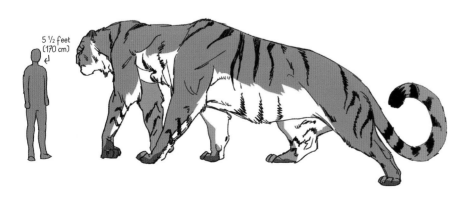

5 ½ feet (170 cm)

1. Design the skeleton from the movement of the animal

If the body is raised, it offsets the balance of the typical feline stance and restricts movement, depending on how the arms are used. The front legs are therefore constructed to be used as both hands and feet. With the "knuckle walk" of gorillas and orangutans as inspiration, I explored poses based on the foremost limbs being used most often as legs with the upper body in a prone position. When searching for prey, the body is raised up and the limbs are used as arms.

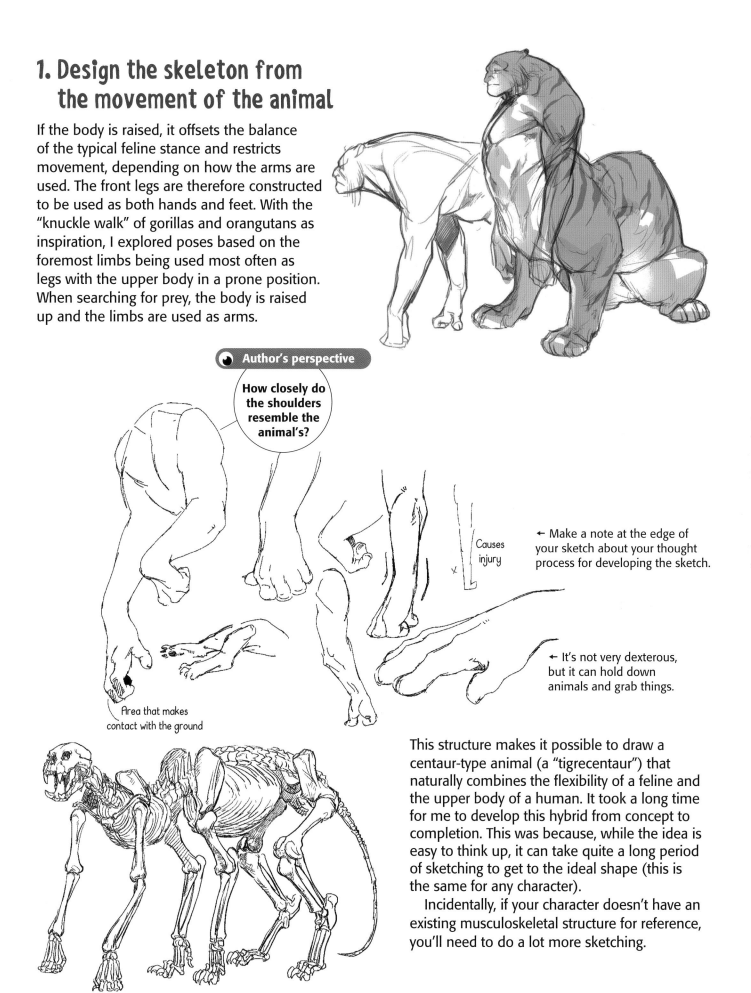

Author's perspective

How closely do the shoulders resemble the animal's?

Causes injury

← Make a note at the edge of your sketch about your thought process for developing the sketch.

← It's not very dexterous, but it can hold down animals and grab things.

Area that makes contact with the ground

This structure makes it possible to draw a centaur-type animal (a "tigrecentaur") that naturally combines the flexibility of a feline and the upper body of a human. It took a long time for me to develop this hybrid from concept to completion. This was because, while the idea is easy to think up, it can take quite a long period of sketching to get to the ideal shape (this is the same for any character).

Incidentally, if your character doesn't have an existing musculoskeletal structure for reference, you'll need to do a lot more sketching.

2. Design a facial structure that contrasts with a human's

Think about the ratio of species-specific characteristics—how much the muscles of a large feline should be combined with a human face? Compared with a human, there's visible weight and mass, even in a two-dimensional character. At the same time, I sketch a lot of actual animals, including felines. The time I take to work on ideas in this way takes at the least two to three months for each character—and at the most nearly two years.

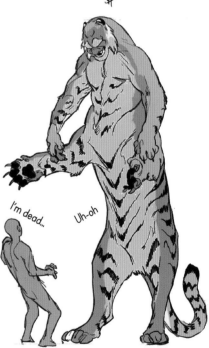

→ Ajai has extremely strong jaw muscles. Its bite force is about 4,975 psi (350 kg/cm²), a little stronger than that of a saltwater crocodile, meaning it can tear the body off of a car like it is tissue paper.

Chomp!

I'm dead... Uh-oh

↑ You can understand how scary it is when compared to a human, as it can fit a human head inside its mouth and its body is more than twice the length of a human's.

↓ Sketches of feline paws. I used the relationship between the joints and how the muscles are actually attached as a skeletal reference.

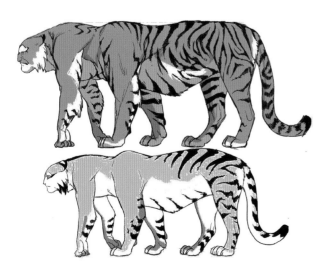

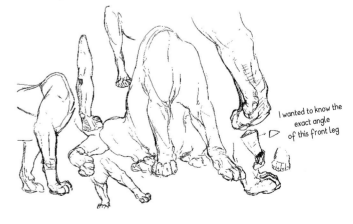

I wanted to know the exact angle of this front leg

3. Design the movement based on form and bone structure

Once you've finalized the form, start sketching movement (and behavior). What is the character interested in? How does it play? Try various perspectives. Being able to make this kind of deformation, in other words, exhibiting the key characteristics, is an indicator of full-featured character creation for me. Only when I've reached the point where I'm able to draw this freely do I feel "now I can start drawing this guy." It's always this way.

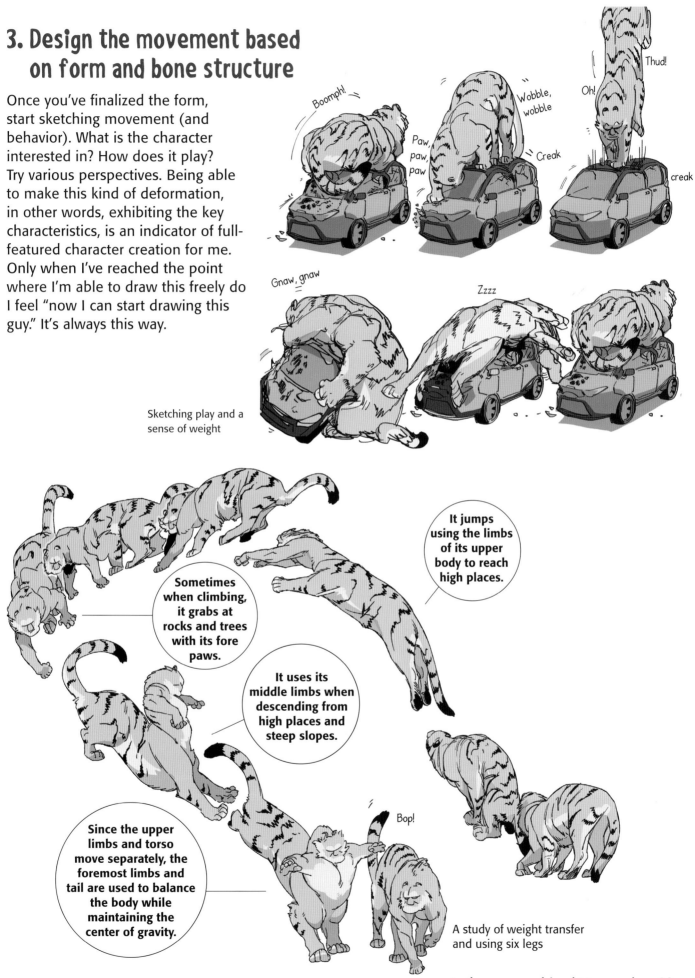

Boomph!

Paw, paw, paw

Wobble, wobble

Creak

Oh!

Thud!

creak

Gnaw, gnaw

Zzzz

Sketching play and a sense of weight

It jumps using the limbs of its upper body to reach high places.

Sometimes when climbing, it grabs at rocks and trees with its fore paws.

It uses its middle limbs when descending from high places and steep slopes.

Since the upper limbs and torso move separately, the foremost limbs and tail are used to balance the body while maintaining the center of gravity.

Bop!

A study of weight transfer and using six legs

Anthropomorphized Mammals 49

Thinking About the Individuality and Characteristics of Horned Animals

Animals with horns, such as deer and sheep, create a strong impression. While they are easy to turn into characters, it's important to create balance with other parts like the personality and behavior, so that the striking physical form is not overpowering.

Making the Best Use of the Horns

Horns are a very strong element when creating a silhouette. So, pay attention to how they are balanced with the body. You can create a powerful impression, even if the body is slender, by changing the size and volume of the horns. For this character, I added clothes made of soft material to accentuate the rigid presence of the horns.

Differences in Forms

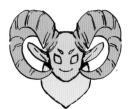

Bighorn Sheep

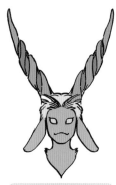

Markhor

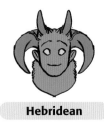

Hebridean

↑ The hooves are also key. You can arrange them in a lot of ways, either leaving them as they are or turning them into hoof-style feet or articulated hands.

Differences in Growth

The following two types of horn are most well-known, but there are said to be five in total, for example, the substantial horn of the rhino.

Antlers

Includes deer. The horns are not attached to the skull and they grow as the animal develops. They may fall off, depending on the season.

Horns

Includes cows. They are protrusions from the skull, with the area around them covered in keratin. They don't fall off.

Horns symbolize "otherness," for example, sometimes in manga and anime the young female attendants that serve at Imperial Court ceremonies have them. They can also be used to represent a phallus or convey the strength of male sexual desire. Females transform into snakes to represent the same principle. An interesting point is that two horns create the impression of an animal, but one horn makes a strange impression. Japan's demons are well-known examples of this uncanny effect.

Impression of Horn Placement

Non-human

The face is clearly visible

Kaijin

Has a large effect on the face

Kaiju

Becomes like an element of the face

Create Interesting Features by Adding Horns

Horned animals may also have other characteristic features. The horns alone give a powerful enough impression, but when combined with other features, they create a unique impression.

↓ Goats are known for their narrow horizontal pupils. When they lower their heads to graze, the eyes rotate to keep the pupils horizontal.

← The color of reindeer eyes becomes a deep blue as summer changes to winter. It's apparently so they can see better in very little light—amazing!

Sumiyoshi's Sketch Notes (Mammals)

These are sketches I drew to use as samples. I focus on the whole body of typical mammals which are familiar to us, such as dogs, cats, wolves and—my personal favorite—horses, as well as details like the limbs, muscles and skeletal structures.

Sketching Mammals (Dogs and Cats)

Many people have dogs, but surprisingly few take the time to observe their physical appearance. I included intricate details in my sketches, like the structure of the legs and skeletal frame that is usually hidden by the fur.

My favorite part of canine anatomy is the tarsal joint! The tautness of the skin that gives a canine appearance is due to the projection of the tarsal joint (a mass of bones in the center), not a bone protrusion.

Straight

The only difference between small and large dogs is the skeletal proportion.

The thin (as seen from the front) upper segment is supported by a single bone, whereas the wider part below the heel is broadened by 5 parallel bones.

The cheekbones around the eyes bulge the most.

The fur makes the dog face bulge and look rounded front-on, so even when drawn from an angle, it tends to get drawn rounded too. The tufts of fur that create this round silhouette are rooted around what would be the cheeks and chin in a human.

→ Fur at the back

Soft and fluffy

Once you have grasped this point, you can express even a fluffy dog at an angle, without losing its fearless impression. If you also lengthen the lines that appear in the foreground, you can add depth.

When you want to illustrate a three-dimensional object through a line drawing, take time to first understand the order of features and landmarks, from foreground to background. And once you get a sense of the form in three-dimensional space, you'll be able to draw it freely.

The Key to Drawing Cats—Understand Their Hidden Bone Structure

Cats have more flexible bodies than dogs and their skeletal structure tends to be concealed in their fur. They're actually quite challenging to draw well.

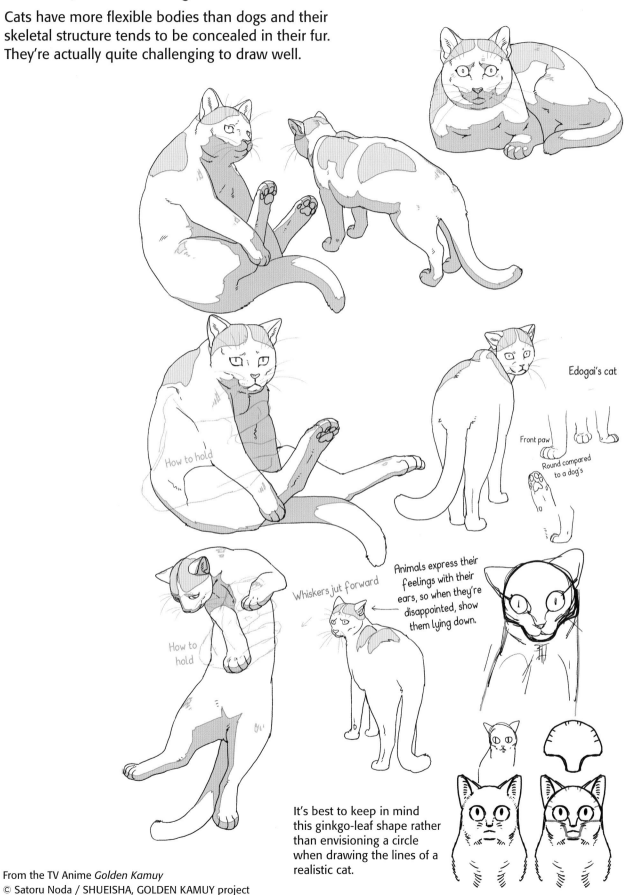

Edogai's cat

Front paw

Round compared to a dog's

How to hold

How to hold

Whiskers jut forward

Animals express their feelings with their ears, so when they're disappointed, show them lying down.

It's best to keep in mind this ginkgo-leaf shape rather than envisioning a circle when drawing the lines of a realistic cat.

From the TV Anime *Golden Kamuy*
© Satoru Noda / SHUEISHA, GOLDEN KAMUY project

Sketching Mammals (Horses and Wolves)

Sketches like these of horses and wolves appeared in the section on key points for basic sketches (refer to page 8) as well. I created them as a reference for muscle volume and paw forms.

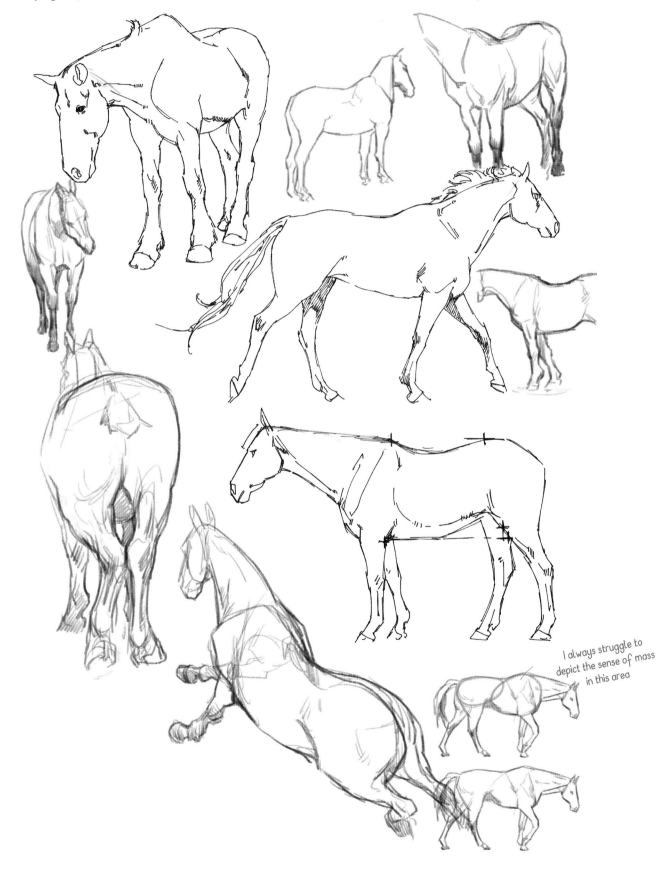

I always struggle to depict the sense of mass in this area

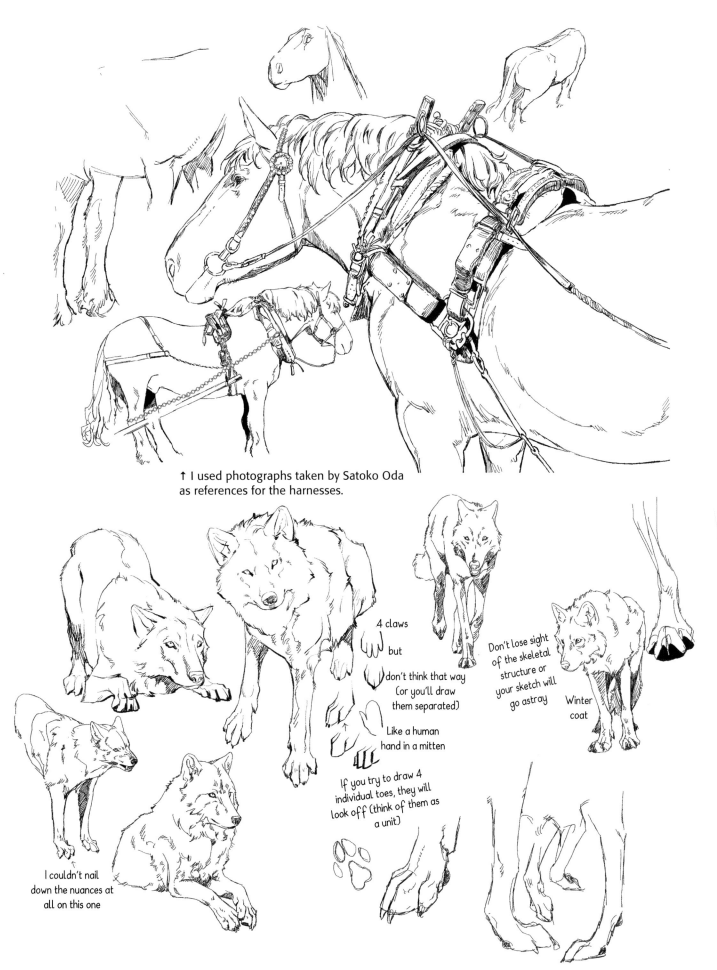

↑ I used photographs taken by Satoko Oda as references for the harnesses.

4 claws

but

don't think that way
(or you'll draw
them separated)

Like a human
hand in a mitten

If you try to draw 4
individual toes, they will
look off (think of them as
a unit)

Don't lose sight
of the skeletal
structure or
your sketch will
go astray

Winter
coat

I couldn't nail
down the nuances at
all on this one

Sketching Mammals (Bears, Whales and Horses)

There is a huge range of mammals. However, many of them share common characteristics and they are all vertebrates. It's amazing how many differences there are between whales and horses, but then, mammalian physiology can be extremely diverse.

If you can find an animal that can serve as a reference for you, it will be a useful basis for noticing differences in proportions and even slight variances in skeletal structure. It's also interesting to see what animals without collarbones have in common too.

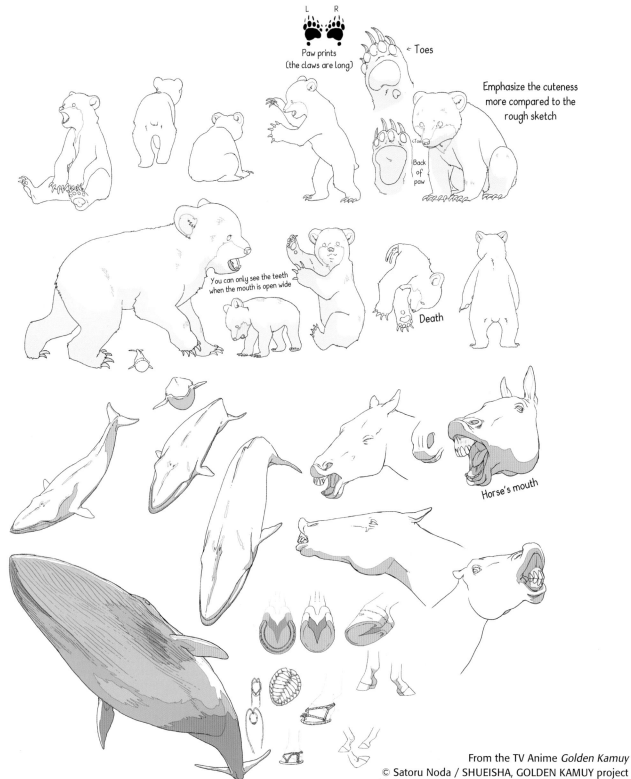

L R
Paw prints
(the claws are long)

← Toes

Emphasize the cuteness more compared to the rough sketch

<Toes

Back of paw

You can only see the teeth when the mouth is open wide

Death

Horse's mouth

From the TV Anime *Golden Kamuy*
© Satoru Noda / SHUEISHA, GOLDEN KAMUY project

CHAPTER **3**
Anthropomorphized Birds and Reptiles

Here, we'll look at birds and reptiles. You'll learn about the structure and characteristics of birds, the descendants of dinosaurs, which are needed for creating fantasy characters, as well as the features of reptiles, which also come in useful for drawing dinosaurs. I've included tips on how to give human-like characteristics to entities very different from mammals too.

Learning About Wing Structure and How Feathers Overlap

Wings are a crucial part for drawing bird characters. It's important to understand wing structure and movement to be able to draw them comfortably. I'll break it down into sections to help you understand it from various viewpoints.

Think of birds and you think of wings. They're their most distinctive feature, and yet the most difficult to express. But you can understand them more easily if you divide them into sections. Save the details for later!

(1) A Comparison Between Human Anatomy and Wing Structure

As this diagram shows, a wing can be divided into sections that are analogous to a certain extent with human body parts.

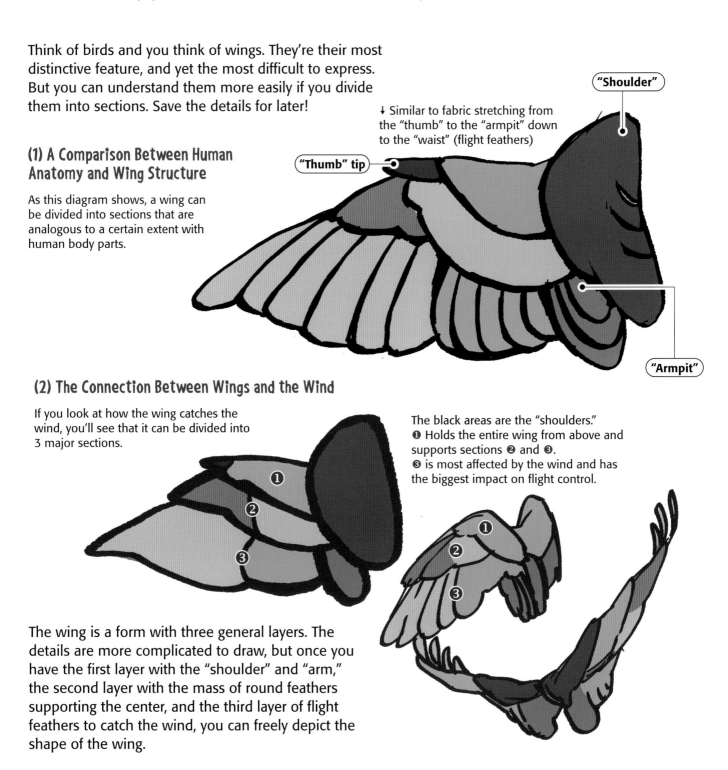

"Shoulder"

↓ Similar to fabric stretching from the "thumb" to the "armpit" down to the "waist" (flight feathers)

"Thumb" tip

"Armpit"

(2) The Connection Between Wings and the Wind

If you look at how the wing catches the wind, you'll see that it can be divided into 3 major sections.

The black areas are the "shoulders."
❶ Holds the entire wing from above and supports sections ❷ and ❸.
❸ is most affected by the wind and has the biggest impact on flight control.

The wing is a form with three general layers. The details are more complicated to draw, but once you have the first layer with the "shoulder" and "arm," the second layer with the mass of round feathers supporting the center, and the third layer of flight feathers to catch the wind, you can freely depict the shape of the wing.

(3) How the Wings Overlap and Fold

Let's look at finer detailed sections to understand how the feathers overlap.

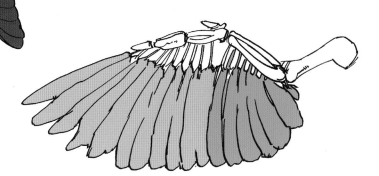

↑ The overlap starts from the inside at the top. Once you know how the wings fold, you won't need to worry about depicting overlap.

↑ The feathers that catch the wind and give the wing its silhouette extend to the "elbow" and the angle turns a little to the inside just before that "elbow."

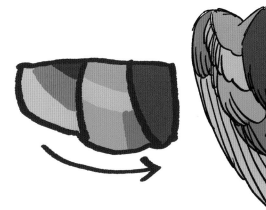

← When the wing folds, the red section in the diagram moves under the blue section.

The shape and proportions of the color-coded wing parts vary greatly depending on the type of bird and the size of its body. You will find it interesting to take a closer look at waterfowl, birds of prey and migratory birds.

Birds are familiar yet elusive and, like reptiles, they are strange and fascinating, being the descendants of dinosaurs.

Creating Bird Characters
(Expressing Anthropomorphic and Nearly-human Traits)

This section explores a specific example of a character based on a bird. Here, I'll explain the process for how I created this Tengu, a legendary creature that appears in folktales.

Think About the Main Character

This is the leader of the Tengu Clan who appears in my original work, *Tsuya-za no Kitsune*. As he's a leader, I gave him the wings of the regal Steller's sea eagle and a chiseled face. The clan includes a lot of fierce individuals, and I needed to convey the wild power he possesses in order to control them, so I gave him an eyepatch to emphasize a stern look. For this character, I started with sketches of kimono and mountain-priest clothing. When sketching, look up the names of the items you need each time and it will make the creation process a lot smoother. The purpose isn't to remember the names—it's to gather materials that you can index and use as keywords for reference whenever you draw.

↑→ Sketches that show how kimono hems fold and wrinkle.

Consider Cultural Development

Cultural development can be indicated by the type of items a character carries, what they wear and how they behave, like wearing straw sandals with catches or flying with their legs crossed. The trick is to have them wearing representative articles and imagine how it moves at the same time. Even for two-dimensional entities, this gives a strong, real-life presence.

They cross their legs to streamline while flying.

The wings come out from under a Suzukake-style kimono.

From above. Not a circle

At an angle

Like this

Addition of a glass bead. A style point.

Tengu *musubi* knot

Sticks out

Crossed legs

The legs are crossed naturally to avoid being affected by wind resistance or getting disrupted and causing loss of balance when flying.

Tengu notes

Those who regularly cross their legs only have the Tengu *musubi* knot on one side.

Only here.

Anthropomorphized Birds and Reptiles 61

Differentiating Individual Characters

Let's think about the characters that are incidental to the main character in a story. When you do this, you'll identify characteristics that can be used as cues, how to categorize them and specific examples of how to develop them.

With any character, it's important to be able to tell at a glance who it is, even when they are in the shadows or only shown in silhouette. The reason you should think about the main character while developing multiple supporting characters is that it makes it easier to conceptualize these "at a glance" differences. If you change the forms and the standing poses, it's an effective way to create differences.

In the case of this Tengu clan, the main focus is a leader who has a graceful, heroic element and magnificent wings. First of all, use the characteristics of the leader to identify the common elements with other characters and the aspects that can be changed to a differentiate them.

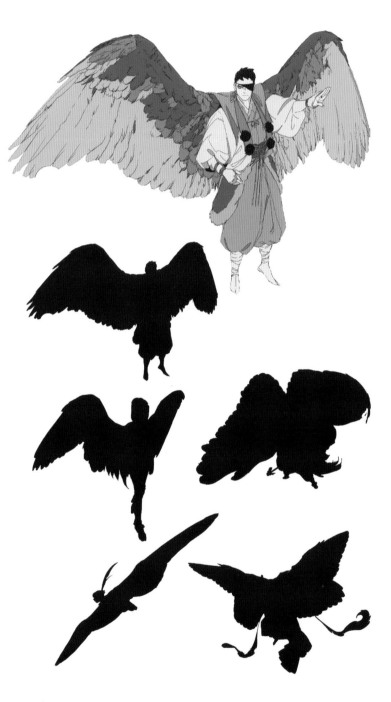

Points in common

Tengu (wings), Japanese style
(Yamabushi mountain priest attire)

Points to change

Each individual's ability (fast flyer / strong flyer) and habitat (forest / mountainside / mountaintop)
Size and shape of wings for that ability / habitat

If you carefully consider the silhouette, you can avoid problems like getting confused with the modeling or having a setting that is so far removed the characters don't look like they're in the same story. This is particularly important in manga and games where a lot of characters appear. It's essential to set criteria and come up with ideas to increase the number of characters.

Specific Examples of Variations

Here, we take a look at side characters that I developed based on the leader's elements.

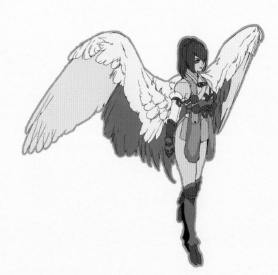

(1) A Female Tengu

I wanted the wings to have an image of strength while staying sleek, so I based them on a large, beautiful Japanese crane. I then added elements like those of a *kunoichi* (female ninja) to the Yamabushi elements to create a feminine form.

(2) A Cold Climate Alpine Tengu

My references were grouse and snowy owls that live in high mountains. You can create more interest through varying the body size. The feature of this Tengu is a mask that covers their face to protect them from the cold. By mixing the bird elements with the authentic look of traditional Japanese performing arts, through the use of articles such as Noh and Kagura masks, an unusual atmosphere is created, while maintaining the attractive avian motif.

(3) A Fast-Flying Tengu

There were a lot of large Tengu that flew majestically, so I added fast-flying ones too. Swallows were an obvious choice for inspiration, but as the leader has blackish wings, I opted for the Australian cockatiel instead as it's also regarded to be a fast flyer. The color and design of that bird are very eye-catching, so I incorporated them by adding a crest as a flourish to the outline and red circles of coloration to the cheeks. Even though it's small, it is very athletic and has a low body fat percentage.

俺より上から物を言うんじゃねえ!!

芝桜より年上だぞ!!

(4) A Fantastical Tengu

Here, I drew a character with a butterfly silhouette, rather than basing it on a bird, to emphasize the fantasy element. I thought about which of the wings should be extended the most to look like four wings. I also tried incorporating butterfly-like movement to them, stretching the wings close to what would be the armpits of the human body, and having them appear to flutter in a delayed way without looking unnatural in any way. For something like this, you need to create an original model, but if you understand the structure of the wing, you can come up with a versatile posture and proportion that doesn't interfere with flying.

Anthropomorphizing Birds—Part I
(Drawing Human-like Creatures)

For commissioned work, you may need to use tones and expressions that you've never considered before. Here, I want to introduce some techniques for creating characters that look familiar, but that also have strong non-human elements, which I found to be challenging at first.

Thinking About a Simple Familiar Human-like Beast Form

This is the main character Naptam that I drew in the short manga collection *Torso no Bokura* (Libre). The story is about a woman who goes on a trip to the Amazon to get over her heartbreak after being betrayed by her lover. She meets a young bird-human there whose culture dictates that he mate for life. The person in charge of the project wanted a light-hearted story that would be accessible to women who enjoy manga, so this gave me the opportunity to formulate an aesthetic I wouldn't normally draw.

The result was the creation of a "beak-inside-the-mouth" model where a creature-like element can be displayed only when desired, even when combined with human facial expressions.

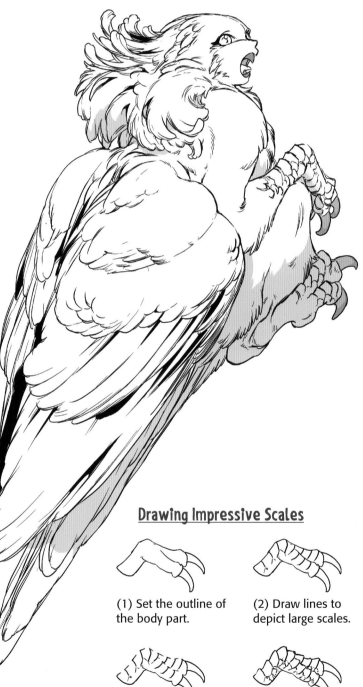

Cheep!

↑ The simplified face is very important in manga. It distills facial details for use in situations that require a quick expression of emotion and an adorable look.

Drawing Impressive Scales

(1) Set the outline of the body part.

(2) Draw lines to depict large scales.

(3) Remove the lines in places where the scales will jut out.

(4) Complete the look as shown in the figure.

Aligning the Color Scheme and Wings with the Story

This character is based on a goshawk. There's a scene where he sweeps up a drowning woman and my idea was to use a color scheme that would make him look like Zorro, the classic outlaw. But his personality was so cute, it didn't feel very Zorro-like.

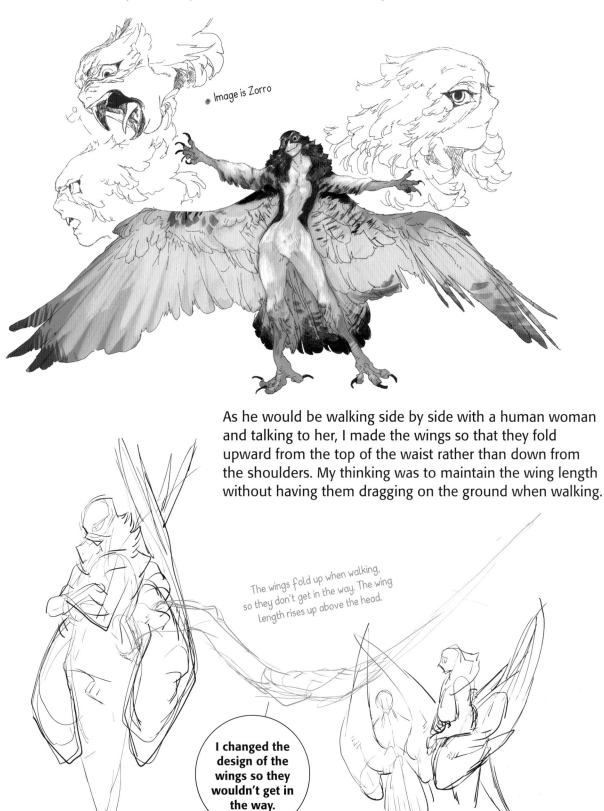

Image is Zorro

As he would be walking side by side with a human woman and talking to her, I made the wings so that they fold upward from the top of the waist rather than down from the shoulders. My thinking was to maintain the wing length without having them dragging on the ground when walking.

The wings fold up when walking, so they don't get in the way. The wing length rises up above the head.

I changed the design of the wings so they wouldn't get in the way.

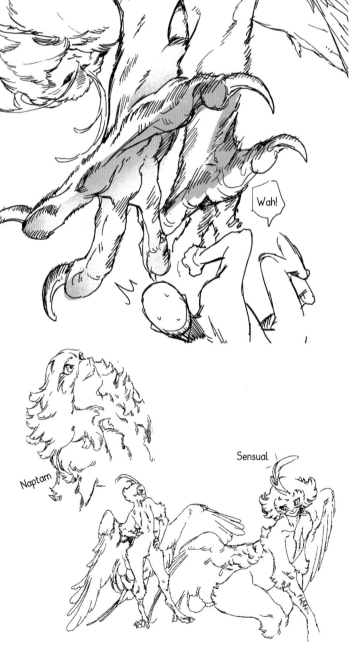

Expressing Powerful and Athletic Bird-man Forms

The chief who raised Naptam is based on an owl and has a rounded, chunky look. I wanted him to look like an enigmatic giant when his wings were folded. This contrasts with Naptam and his athletic, lively form.

Wah!

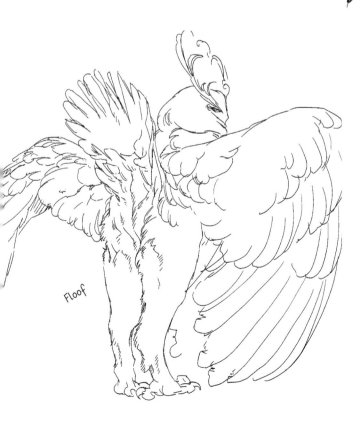

Floof

Naptam

Sensual

Sketch notes

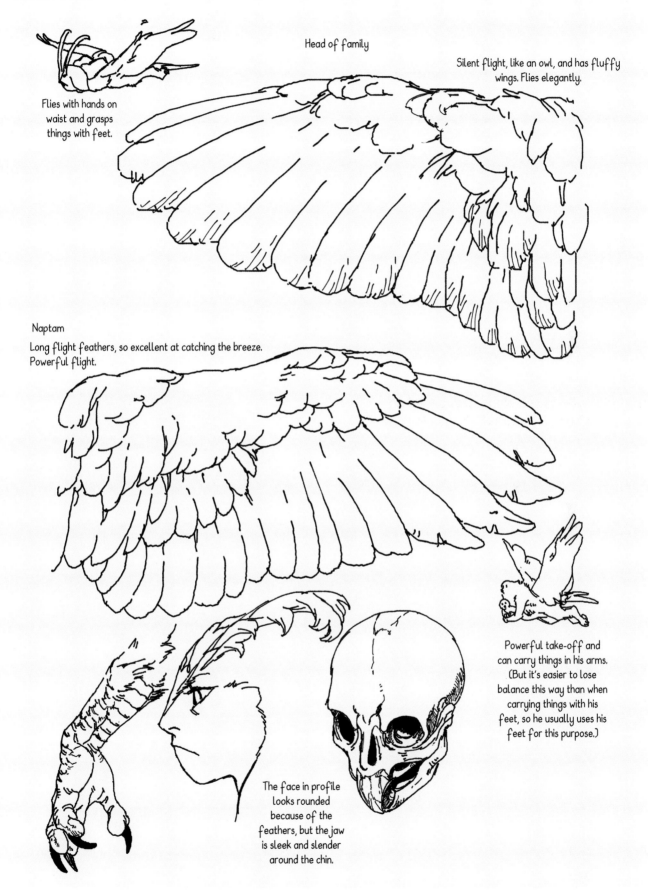

Flies with hands on waist and grasps things with feet.

Head of family

Silent flight, like an owl, and has fluffy wings. Flies elegantly.

Naptam

Long flight feathers, so excellent at catching the breeze. Powerful flight.

Powerful take-off and can carry things in his arms. (But it's easier to lose balance this way than when carrying things with his feet, so he usually uses his feet for this purpose.)

The face in profile looks rounded because of the feathers, but the jaw is sleek and slender around the chin.

Anthropomorphizing Birds—Part II
(Drawing Creatures)

This is an example of anthropomorphic birds developed into fantastical creatures. To align the character with the backstory, try adjusting the structure, coloration and other expressions of its individuality.

This is Barry, a type of beast with a human face and based on a southern cassowary, which I created after being inspired by the world featured in the work of Suzumori (@submori_521). This is fan art that I drew after receiving permission because I found the fantasy world very inspiring and wanted to try emulating it at least once.

As many of the human-like beast designs have faces similar to humans, I explored creating a form with the structure of the beak concealed inside the mouth as with Naptam. I avoided including elements from my own work that didn't fit with Suzumori's imagined world and explored incorporating characters that wouldn't look out of place.

Twists round

← The beak automatically pops out when the mouth is opened. I was inspired by macaws, which can move their upper and lower mandibles separately, and moray eels, which have two sets of jaws.

Creating the Movement of a Living Thing

Let's think about movement as part of the way of life, including the individual differences and characteristics. I incorporated the nature of a real living thing into the character's personality too.

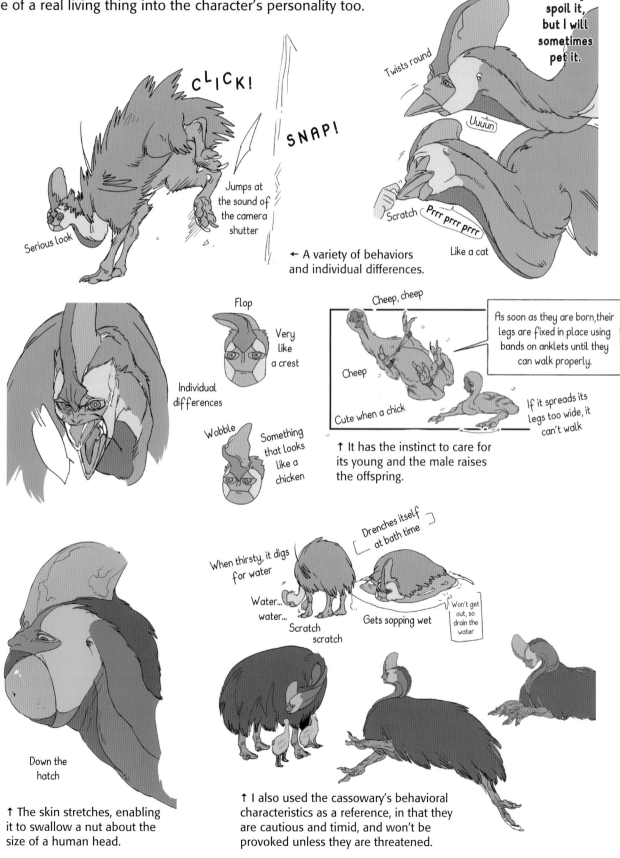

CLICK!

SNAP!

Serious look

Jumps at the sound of the camera shutter

I rarely spoil it, but I will sometimes pet it.

Twists round

Uuuun

Scratch Prrr prrr prrr

Like a cat

← A variety of behaviors and individual differences.

Flop

Very like a crest

Individual differences

Wobble

Something that looks like a chicken

Cheep, cheep

Cheep

Cute when a chick

As soon as they are born, their legs are fixed in place using bands on anklets until they can walk properly.

If it spreads its legs too wide, it can't walk

↑ It has the instinct to care for its young and the male raises the offspring.

When thirsty, it digs for water

Drenches itself at bath time

Water... water...

Scratch scratch

Gets sopping wet

Won't get out, so drain the water

Down the hatch

↑ The skin stretches, enabling it to swallow a nut about the size of a human head.

↑ I also used the cassowary's behavioral characteristics as a reference, in that they are cautious and timid, and won't be provoked unless they are threatened.

Anthropomorphizing a Wolf-Bird Hybrid
(Drawing Creatures)

This character combines a wolf and bird, blended to fit in with the original fantasy world concept. Depending on which elements you choose, you may create something closer to a mythical creature, but it's important to stay aware of the characteristics and distinctions and be able to communicate them in your own way.

This character, Tenro, is a character sketch I created of a bird that inhabits the same world as Ajai (see page 46). I emphasized the six-limb form, one of the common features in *Shinwa no Kemono* (where six-limbed human-faced beasts are common) and I designed it using key features of birds, while making sure it didn't too closely resemble the mythical Griffin.

I didn't include nostrils, which tend to give a stronger beast-like impression, and I lengthened the snout to create a bird-like silhouette even without a beak, while retaining some of the features of a human face. In addition, I laid out the body in such as way as to make clear that even though the character has multiple limbs, it doesn't use them like a mammal and instead relies on the talon-hands on its wings.

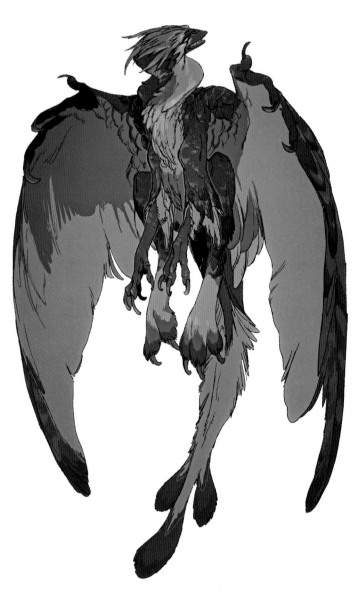

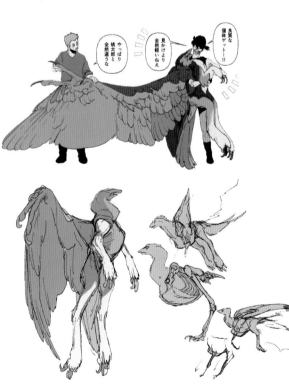

← I thought about how the four legs can move without being obstructed by the wings and adjusted the ratio of bird to mammal for the length of the body and how the legs joined up to it.

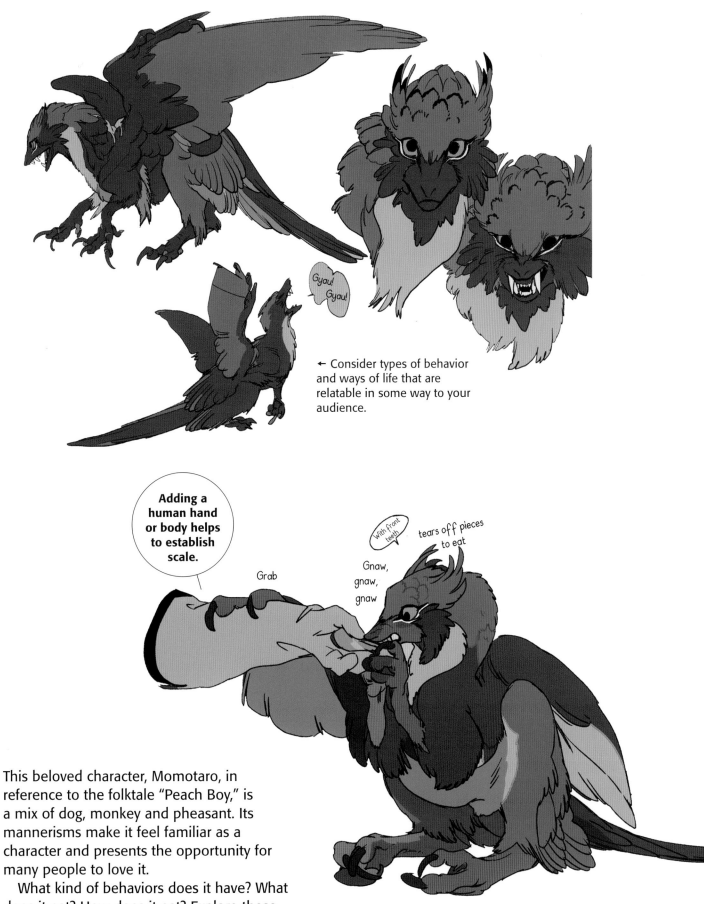

← Consider types of behavior and ways of life that are relatable in some way to your audience.

Gyau! Gyau!

Adding a human hand or body helps to establish scale.

Grab

With front teeth

tears off pieces to eat

Gnaw, gnaw, gnaw

This beloved character, Momotaro, in reference to the folktale "Peach Boy," is a mix of dog, monkey and pheasant. Its mannerisms make it feel familiar as a character and presents the opportunity for many people to love it.

What kind of behaviors does it have? What does it eat? How does it eat? Explore these questions in depth through your sketches.

Sumiyoshi's Sketch Notes (Birds)

You should pay close attention to the motifs that you think you know just because you see them often. It's important not to think of a bird as a bird, but as something you're seeing for the first time and ask yourself, "What is this?"

Sketching Birds

It's important in sketching to understand what areas of the motif you are looking at. An easy way to do this is to look at the whole subject, and then hide a part of it and try to draw the part you can't see. By doing this exercise, your observational skills will become sharper. Alternatively, you can focus in on the area you want to observe closely and remove any unnecessary details to make it easier to concentrate.

↑ Conceal part of a familiar form.

↑ Fill in the blanks from memory.

Caaw!

Ruffle

Sketching Crows

I sketch the appearance of the feathers, legs and claws, as well as how the tail feathers catch the wind. It can help to try color-coding the parts you're interested in. This way, it will be easier to understand the animal's poses, including their appearance from a variety of angles.

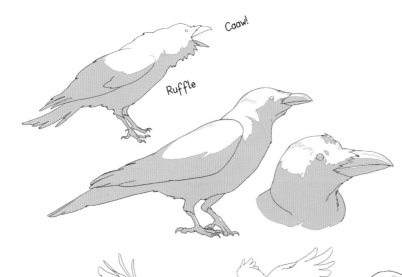

From the TV Anime *Golden Kamuy*
© Satoru Noda / SHUEISHA, GOLDEN KAMUY project

Sketching Vultures

Use simple line drawings to depict birds in the distance and add details to the ones that are closer.

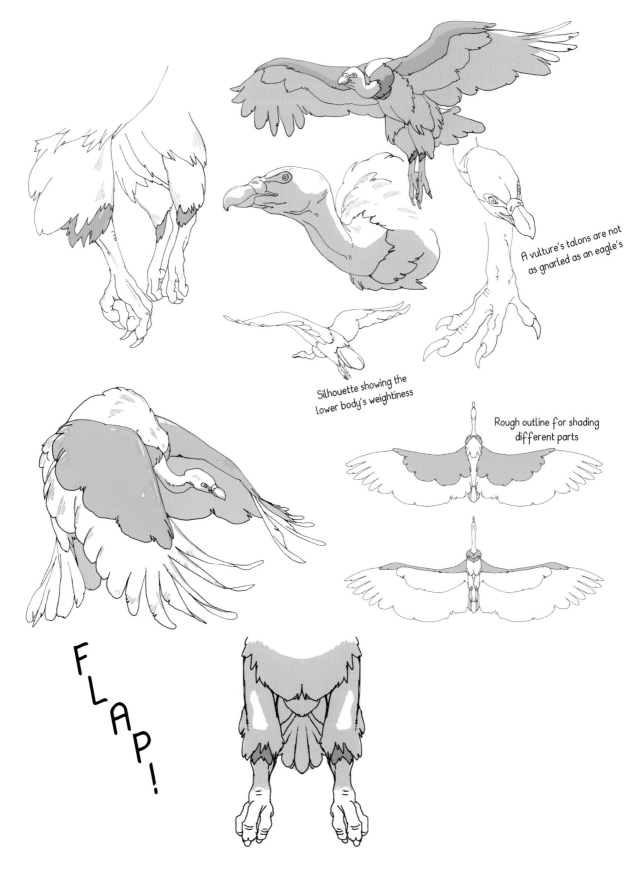

A vulture's talons are not as gnarled as an eagle's

Silhouette showing the lower body's weightiness

Rough outline for shading different parts

FLAP!

Sketching Steller's Sea Eagles

A character designer is a conceptual architect. People will be creating animation and 3D models based on your sketches, so it's best to provide as much material as possible in an easy-to-understand manner so there's no ambiguity. I draw a lot of poses that either haven't been requested or that end up not actually being used, just to cover all possible eventualities.

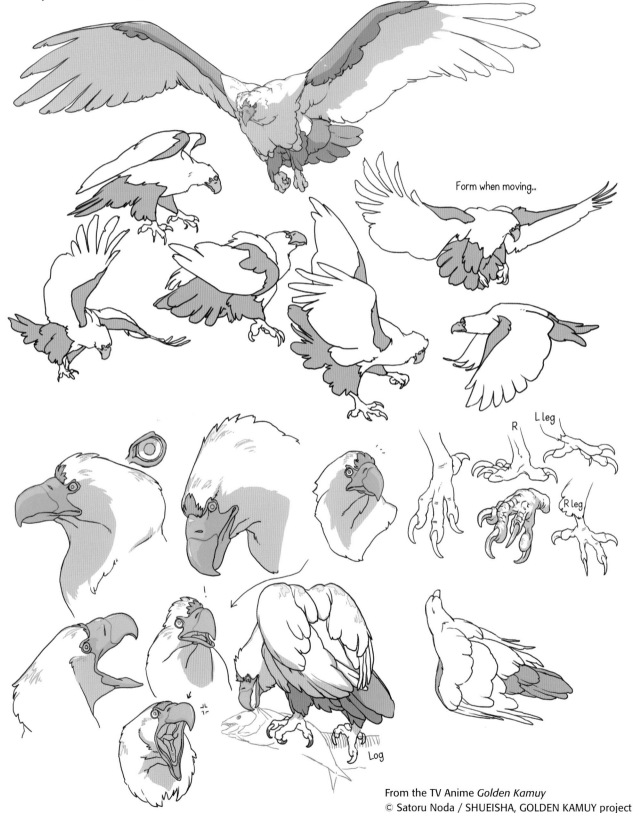

Form when moving...

R L leg

R leg

Log

From the TV Anime *Golden Kamuy*
© Satoru Noda / SHUEISHA, GOLDEN KAMUY project

The Fascinating Dinosaur Connection Between Birds and Reptiles

Birds are said to be descended from dinosaurs. They may seem far removed from the image of a large reptilian form, but if you look at the legs of an ostrich or emu, you can definitely see the connection.

The pteranodon, which resembles a bird, is strictly speaking related to dinosaurs and classified as a reptile. That's why this chapter covers birds and reptiles. If you know how to draw both, it will be easier for you to draw not only the pteranodon, but other dinosaurs and dragons based on dinosaurs too. They are indispensable characters when it comes to fantasy.

Incidentally, I regularly get the urge to draw dinosaurs, and whenever that happens I try to draw a story about a human clan living in a cold climate with dinosaurs. My inspiration is the styracosaurus, a horned dinosaur, and protoceratops, a small herbivorous dinosaur. I love the shoulder bones of the styracosaurus, especially the length of its scapula and deltoid bulge, as the distance between them is similar to that of the human elbow.

I sketched the diabloceratops below as reference for that work too. It is a herbivorous dinosaur that has two horns on its neck (its name means "devil-horned face"), but it's not possible to tell the shape of the cheeks from the bone structure, so I had fun designing it to look like a reptile or mammal.

The Cretaceous Period, when dinosaurs existed, seems to have been a super-sized world. But the dinosaurs that populated that period didn't survive in their original state through to today, of course. This may have been the result of climate change, food scarcity or other factors. The reasons can only be guessed at from fossils and the look of their descendants, the birds and reptiles, but I find it a mysterious and fascinating part of prehistory.

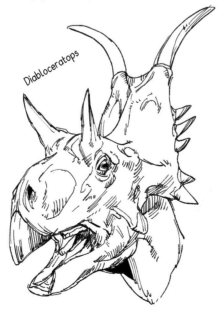

Diabloceratops

Learn the Structure and Emotional Expressions of Reptiles

Reptiles seem to have unreadable expressions. The truth is though, if you closely observe them, you'll see that they express emotions with their whole body. Knowing how they live will help you quickly build a sense of attachment and interest so you can create your character.

Observe Emotional Expressions and Behavior

It may seem like reptiles have no expressions because they don't have facial muscles, but this isn't the case. They have their own unique expressions. For example, when a lizard gets angry it inflates its body and its head crest changes color.

Tree monitor

Basilisk

↑ They inflate to look as large as possible and make a hissing or puffing noise. When they're really angry, they do push-ups!

→ Fast-moving lizards run away, but those lacking speed use their strong tails to attack when provoked. Their tails consist of a mass of muscle, and larger species can easily break thinner glass with their tails.

↑ Some species can change the color of their head crest or extend it.

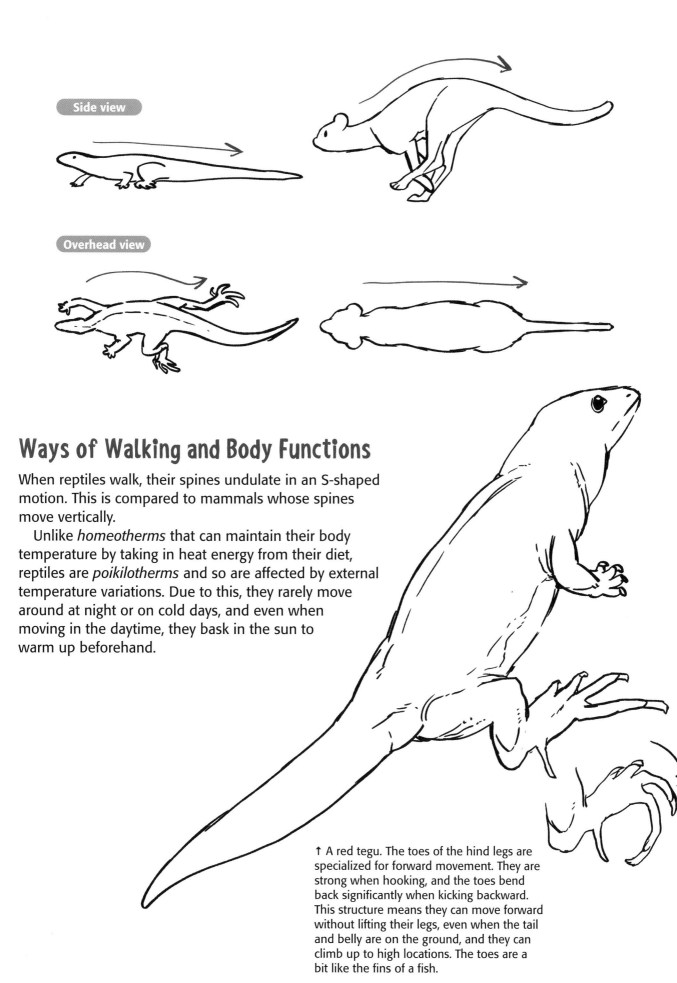

Ways of Walking and Body Functions

When reptiles walk, their spines undulate in an S-shaped motion. This is compared to mammals whose spines move vertically.

Unlike *homeotherms* that can maintain their body temperature by taking in heat energy from their diet, reptiles are *poikilotherms* and so are affected by external temperature variations. Due to this, they rarely move around at night or on cold days, and even when moving in the daytime, they bask in the sun to warm up beforehand.

↑ A red tegu. The toes of the hind legs are specialized for forward movement. They are strong when hooking, and the toes bend back significantly when kicking backward. This structure means they can move forward without lifting their legs, even when the tail and belly are on the ground, and they can climb up to high locations. The toes are a bit like the fins of a fish.

The Relationship Between Reptile Poses and Facial Expressions

Reptile facial expressions are expressed through the eyes, jaws and fangs. The shape and structure of a living thing is directly linked to its way of life and habitat. A reptile's form is very different from that of mammals, but if you pay attention to their movements, it is easier to understand the factors that affect their physical appearance.

Reptiles may not have human-like expressions, but many have eyelids. When they are feeling warm and comfortable, their lower eyelids slowly rise up like a bird's—as if laughing—and it looks cute. By the way, snakes don't have eyelids, but their eyes aren't exposed because they're covered by transparent scales. So they can keep their eyes wide open, even when chasing prey.

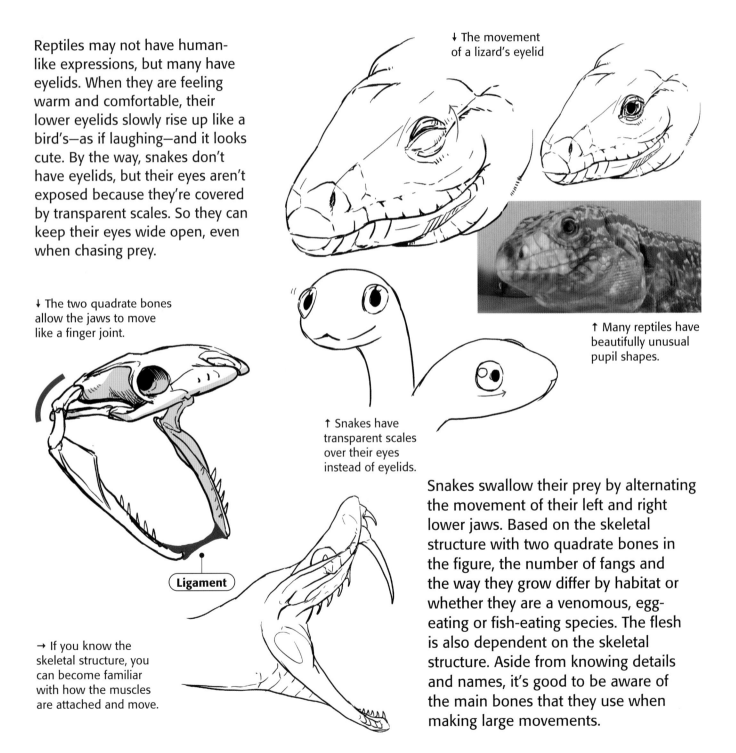

↓ The movement of a lizard's eyelid

↑ Many reptiles have beautifully unusual pupil shapes.

↓ The two quadrate bones allow the jaws to move like a finger joint.

Ligament

→ If you know the skeletal structure, you can become familiar with how the muscles are attached and move.

↑ Snakes have transparent scales over their eyes instead of eyelids.

Snakes swallow their prey by alternating the movement of their left and right lower jaws. Based on the skeletal structure with two quadrate bones in the figure, the number of fangs and the way they grow differ by habitat or whether they are a venomous, egg-eating or fish-eating species. The flesh is also dependent on the skeletal structure. Aside from knowing details and names, it's good to be aware of the main bones that they use when making large movements.

Many reptiles have formidable fangs. They can't usually be seen as they're concealed within the gums, but never forget they are there!

Skull

Shining eyes

Gila monster

Lizards use their feet to crawl forward across land, so their outer claws are perpendicular to the ground. Stocky lizards have muscles that make the spine look concave as the flesh on either side is raised. Conversely, the spine on thinner lizards will stick out, but this is the same for all vertebrates (the more muscle mass they have, the thinner the joints look, and if they are undernourished, the joints look broader).

The skeletal structure of living things is determined by their way of life. It all has a significant relationship to their movement, so if you have difficulty understanding something just by its form, take a look at the way it moves. Their unusual shape should make sense then.

Foot

↑ A red tegu's feet are small and cute like a baby's.

Making the Most of Reptilian Features in Character Designs

The key point here is to blend reptilian characteristics with human facial expressions. If you can observe something, then all you need to do is learn how to draw it. Look for expressions that make you think "Voilà!" by combining the forms you observe and then adjusting the amount of detail you use.

Adding Human Expressions to Reptilian Faces

Human facial expressions are essential for anthropomorphizing reptiles. This is because the lack of facial muscles makes it difficult to use only reptilian elements to express emotions that are easily readable by humans. Keep some key elements that are different from humans, like the side-facing eyes, long nasal bridge and hairless head, and use wrinkles and lips to add facial expressions around the eyebrows and mouth.

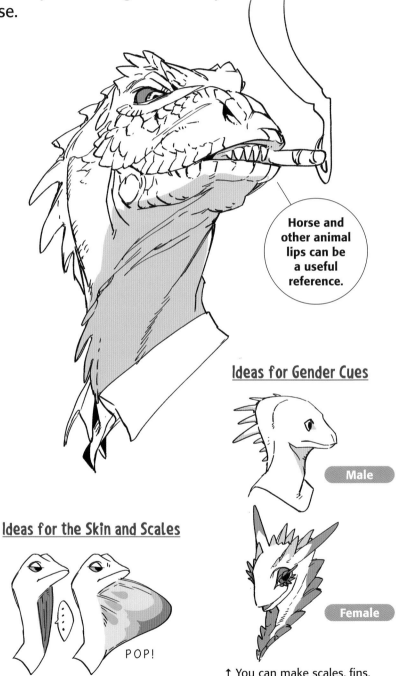

Horse and other animal lips can be a useful reference.

Ideas for the Mouth

← The large mouth with corners that run right to the ears is characteristic of reptiles. When you combine it with a human face, you can emphasize the look of a snake hybrid.

← The stretched mouth makes it look like the character is laughing, so when you want to reduce that impression, add scales to the upper jaw to conceal the sides of the mouth. This also increases the contrast apparent when it opens its mouth.

Ideas for the Skin and Scales

POP!

↑ Even if the facial expressions are the same, you can change the emotions or display different personality characteristics by modifying the skin and scales.

Ideas for Gender Cues

Male

Female

↑ You can make scales, fins, and horns look like eyelashes, collars, ears and other parts of the body, so you can change the gender and impression, while retaining a sense of rigidity.

Adjust the Detail of the Scales

Reptile scales are made of the same keratinous substance as human nails and hair. If you try to draw them too accurately, it will be difficult as they're detailed and rough, plus some people may find them repulsive. The way to avoid this is to adjust the amount of detail you include while drawing the scales.

Realistic

Bold

If you dare to draw large, prominent scales, it creates a cool characteristic. If you want to depict a natural flow, change the size from small to medium to large and then back to medium as shown in the figure, paying attention to the flow of the outline.

Understated

Emphasize the scales at the joints (where they move) so they are somewhat spiky, and reduce the appearance of the rest down to simple lines. For the outline, make sets of small lines with less detail, so that it gives a tidy impression.

Fill in the silhouette to get an easier understanding of the impression created. If you think about the appropriate volume and amount of detail for the character you want to draw, any version you use will look stylish.

Anthropomorphizing Reptiles
(Drawing Human-like Creatures)

Reptile scales and fins can come to life in a story, serving a similar function to fur. Here, you'll learn how to draw these elements more effectively. I'll also show you how optical illusions work, so you can make a large impact with very little effort.

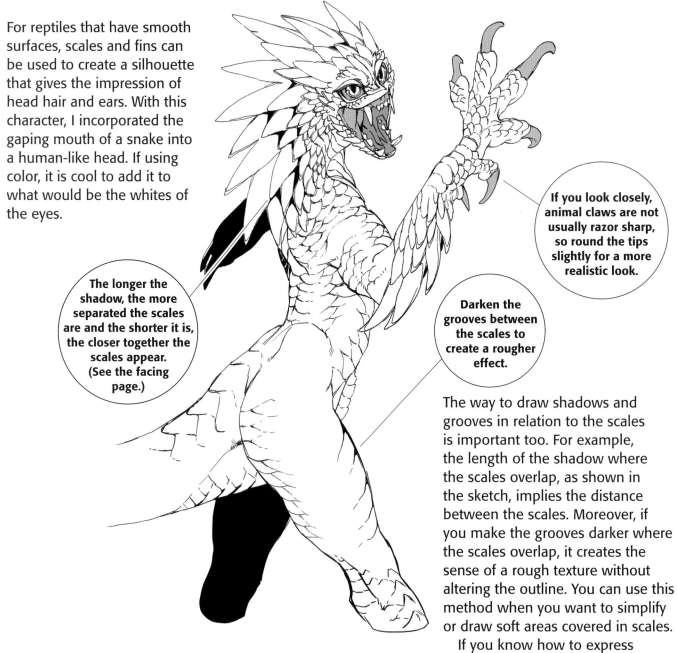

For reptiles that have smooth surfaces, scales and fins can be used to create a silhouette that gives the impression of head hair and ears. With this character, I incorporated the gaping mouth of a snake into a human-like head. If using color, it is cool to add it to what would be the whites of the eyes.

The longer the shadow, the more separated the scales are and the shorter it is, the closer together the scales appear. (See the facing page.)

If you look closely, animal claws are not usually razor sharp, so round the tips slightly for a more realistic look.

Darken the grooves between the scales to create a rougher effect.

The way to draw shadows and grooves in relation to the scales is important too. For example, the length of the shadow where the scales overlap, as shown in the sketch, implies the distance between the scales. Moreover, if you make the grooves darker where the scales overlap, it creates the sense of a rough texture without altering the outline. You can use this method when you want to simplify or draw soft areas covered in scales.

If you know how to express these techniques, you can create suggested presence without the need to draw strong texture or minute details.

When drawing the scales, the three-dimensional effect of the figure is key. The way the scale pattern runs across the body can hinder your ability to visualize the three-dimensional form, so at the rough draft stage, just draw the general outline, indications of mass and indentations of the body.

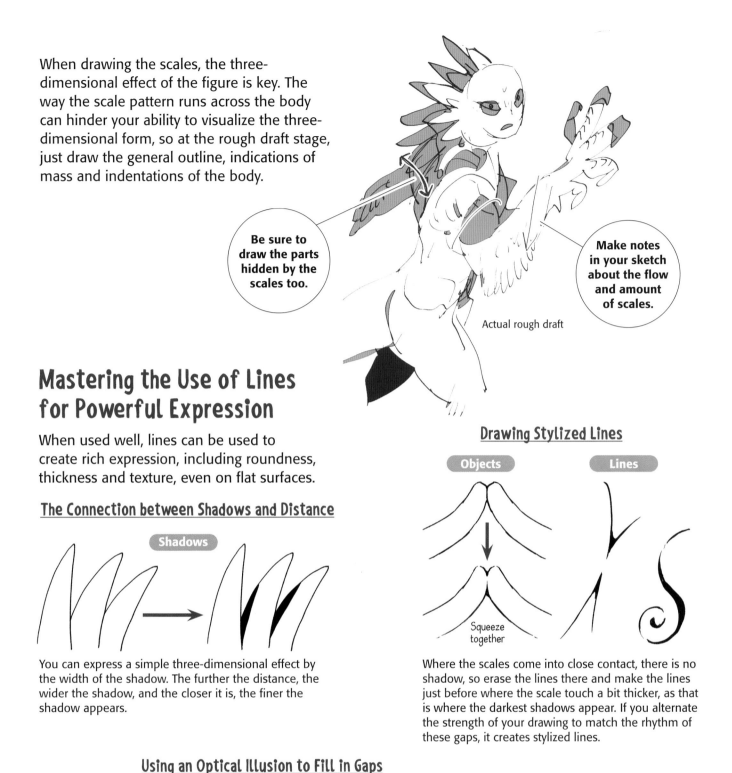

Be sure to draw the parts hidden by the scales too.

Make notes in your sketch about the flow and amount of scales.

Actual rough draft

Mastering the Use of Lines for Powerful Expression

When used well, lines can be used to create rich expression, including roundness, thickness and texture, even on flat surfaces.

The Connection between Shadows and Distance

Shadows

You can express a simple three-dimensional effect by the width of the shadow. The further the distance, the wider the shadow, and the closer it is, the finer the shadow appears.

Drawing Stylized Lines

Objects

Lines

Squeeze together

Where the scales come into close contact, there is no shadow, so erase the lines there and make the lines just before where the scale touch a bit thicker, as that is where the darkest shadows appear. If you alternate the strength of your drawing to match the rhythm of these gaps, it creates stylized lines.

Using an Optical Illusion to Fill in Gaps

Reduction Process

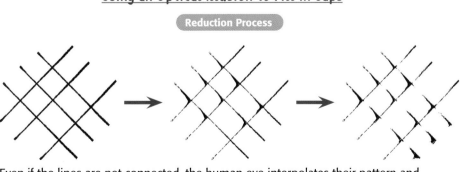

Even if the lines are not connected, the human eye interpolates their pattern and perceives them as such. You can use this to create elegant implied lines without increasing the amount of visual information in the design.

Creating Snake Characters
(Drawing Yokai)

Among reptiles, snakes have the most unusual form. Here, I'll introduce some ideas on how to make the most of this interesting aspect and what motifs can be used to express the humans characteristics of the creature.

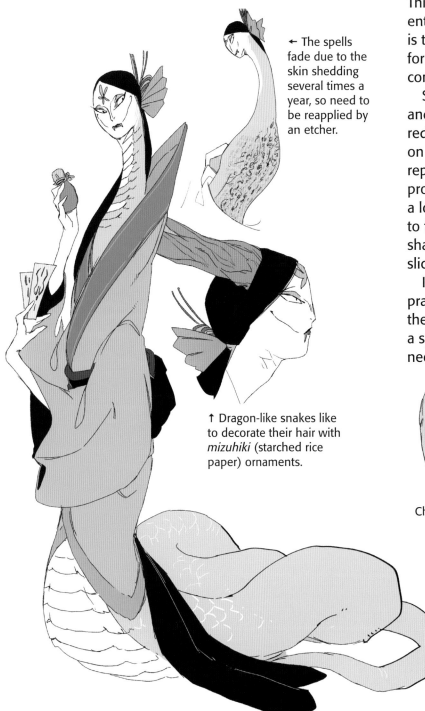

← The spells fade due to the skin shedding several times a year, so need to be reapplied by an etcher.

↑ Dragon-like snakes like to decorate their hair with *mizuhiki* (starched rice paper) ornaments.

This is Shiun, a snake *yōkai* (supernatural entity). The assumption for this character is that, no matter how far removed its form is from a human's, it can speak and communicate with people.

Snakes are the ultimate efficient creature and even if they grew limbs, they would be redundant. It took me a long time to settle on this figure. I used a Chūjō Noh mask, representing a young man experiencing profound grief, as reference for the face. I did a lot of trial and error to get the long neck to fit without any extra decoration, including shaping the kimono to look like diagonally-sliced bamboo.

I also came up with the idea of an occult practice where they have spells etched onto their bodies so that they can use magic. Once a spell has faded due to skin shedding, they need to have it reapplied.

Chūjō Noh mask

→ I balanced the silhouette of a character with a long neck by giving it a large diagonal kimono collar.

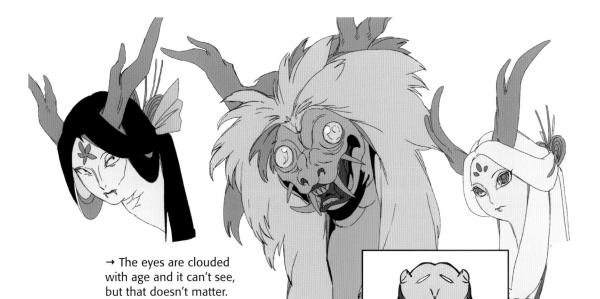

→ The eyes are clouded with age and it can't see, but that doesn't matter.

Here, I referred to Noh and Kagura masks and added snake elements to explore the balance between humans and snakes. One of the references I found helpful for combining a human-like face with a snake was the Iwami Kagura masks of Hamada City, Shimane Prefecture. Deformation in Japanese folk art is a wonderful balance of being both human and animal and yet neither, and I often refer to it.

When your conceptual sketching is complete, draw a lot of poses and close-ups of the face (from different angles) to familiarize yourself with the design.

Use folk art and classical performing arts expressions for reference.

The original Iwami Kagura mask from Hamada City

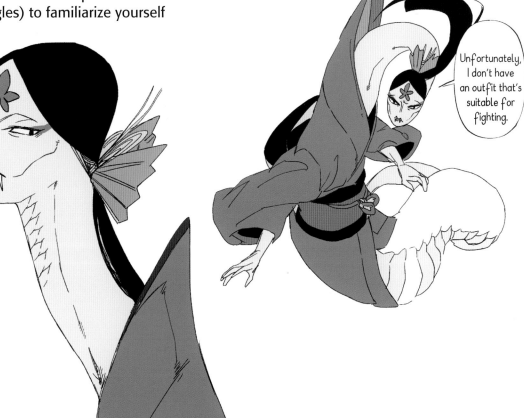

Unfortunately, I don't have an outfit that's suitable for fighting.

Anthropomorphizing Dino-taurs

The key point here is to blend reptilian characteristics with human facial expressions. If you can observe something, then all you need to do is learn how to draw it. Look for expressions that make you think, "Voilà!" by combining the forms you observe and then adjusting the amount of detail you use.

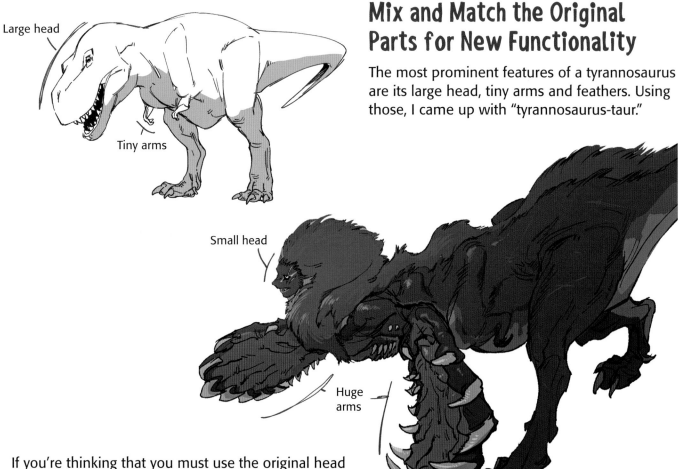

Large head

Tiny arms

Small head

Huge arms

Mix and Match the Original Parts for New Functionality

The most prominent features of a tyrannosaurus are its large head, tiny arms and feathers. Using those, I came up with "tyrannosaurus-taur."

If you're thinking that you must use the original head form as the head on your new creation, you won't be able to be very original. Once you move away from the big-head-and-small-arms paradigm though, and think about the role of each part, you can sometimes come up with unexpected expressions.

In the case of this character, I changed the famed tyrannosaurus mandibles into arms. By placing the fingers like teeth, the arms become huge jaws—the need for a massive head is discarded. I lengthened the neck to make it easier for the character to consume its defeated prey and, in effect, gave it a maw that combined the jaws and arms of the tyrannosaurus. Instead of feathers, I added a leonine mane that exhibits the texture of emu feathers.

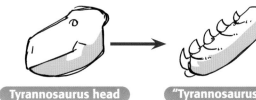

Tyrannosaurus head

↑ Its roles are chewing prey and creating balance for the whole body.

"Tyrannosaurus-taur" arm

↑ The fingers are placed like teeth to make huge jaw-arms (a change in function).

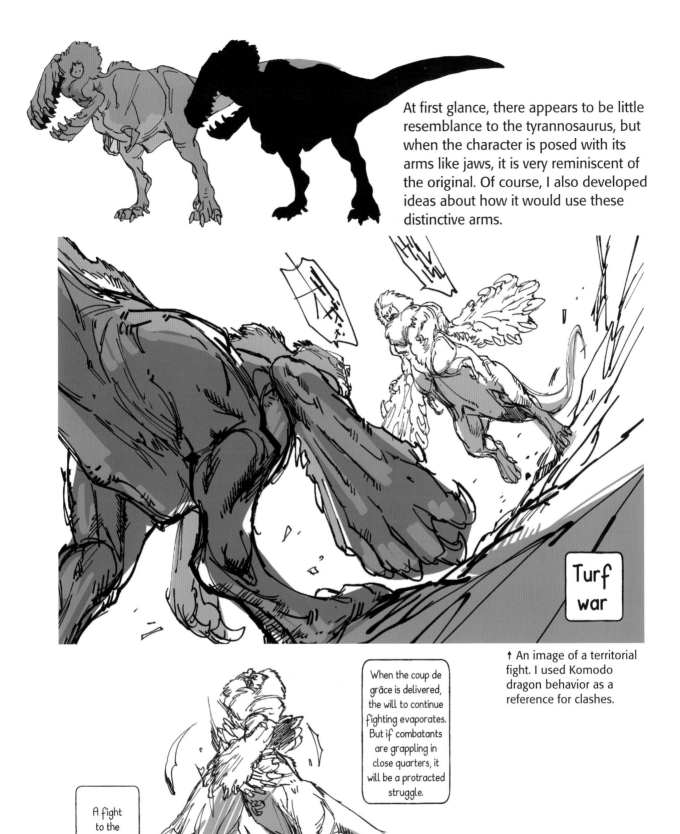

At first glance, there appears to be little resemblance to the tyrannosaurus, but when the character is posed with its arms like jaws, it is very reminiscent of the original. Of course, I also developed ideas about how it would use these distinctive arms.

Turf war

↑ An image of a territorial fight. I used Komodo dragon behavior as a reference for clashes.

When the coup de grâce is delivered, the will to continue fighting evaporates. But if combatants are grappling in close quarters, it will be a protracted struggle.

A fight to the death.

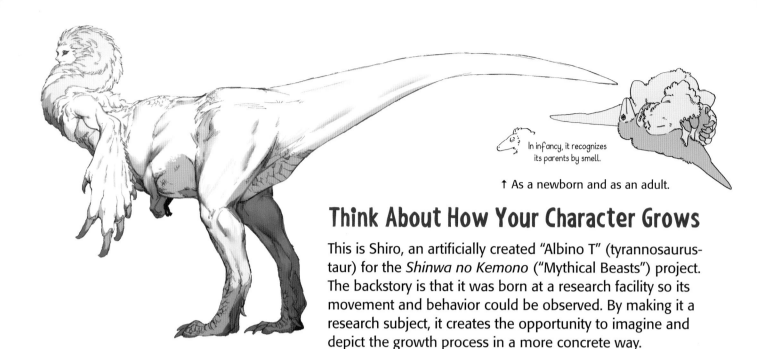

In infancy, it recognizes its parents by smell.

↑ As a newborn and as an adult.

Think About How Your Character Grows

This is Shiro, an artificially created "Albino T" (tyrannosaurus-taur) for the *Shinwa no Kemono* ("Mythical Beasts") project. The backstory is that it was born at a research facility so its movement and behavior could be observed. By making it a research subject, it creates the opportunity to imagine and depict the growth process in a more concrete way.

Growth comparison between Shiro and Baoshi (a six-limbed large feline like Ajai) from *Shinwa no Kemono*.

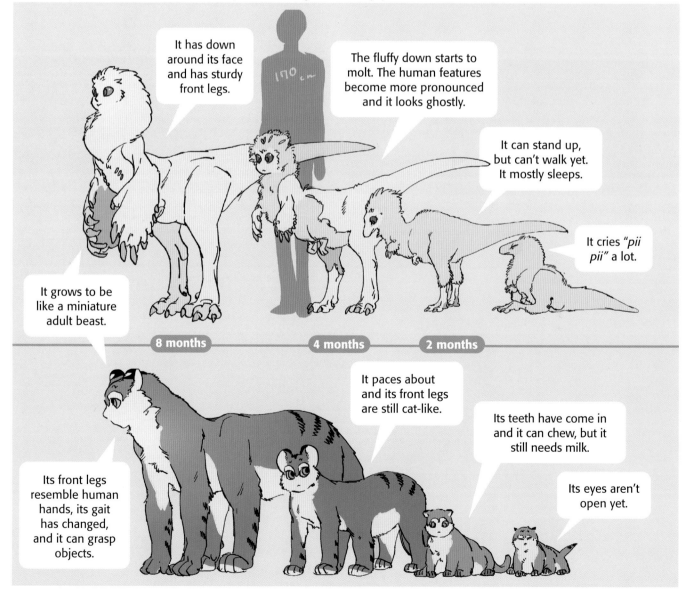

It has down around its face and has sturdy front legs.

The fluffy down starts to molt. The human features become more pronounced and it looks ghostly.

It can stand up, but can't walk yet. It mostly sleeps.

It cries *"pii pii"* a lot.

It grows to be like a miniature adult beast.

8 months　　**4 months**　　**2 months**

It paces about and its front legs are still cat-like.

Its teeth have come in and it can chew, but it still needs milk.

Its front legs resemble human hands, its gait has changed, and it can grasp objects.

Its eyes aren't open yet.

Think About the Growth Process and Role of the Body

As you draw your character in action, think about how it uses its small arms. For example, a male anaconda has vestigial remnants of hind legs (claw-like spurs) that it seems to use to prepare a female's body for mating. There is a theory that the tyrannosaurus used its limbs similarly. With these types of examples in mind, try showing the limbs making gestures that are used to communicate.

Drawing the relationship between the character and humans can help to establish scale and show how their body proportions change as they grow. This is a good way to strengthen a character's presence too.

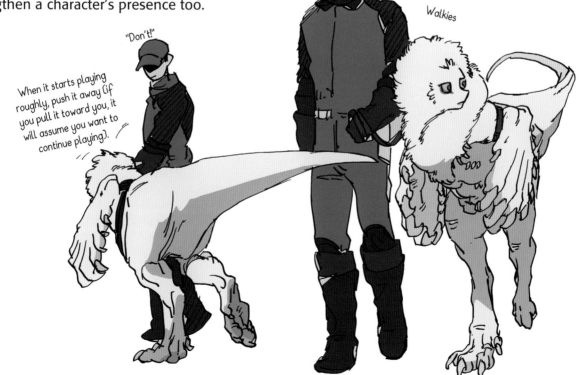

"Don't!"

When it starts playing roughly, push it away (if you pull it toward you, it will assume you want to continue playing).

Walkies

Think About the Size of Your Character

The size of a creature can greatly alter the impression it gives. So when you're deciding on the setting for a character, think not only about its shape and personality, but its size too.

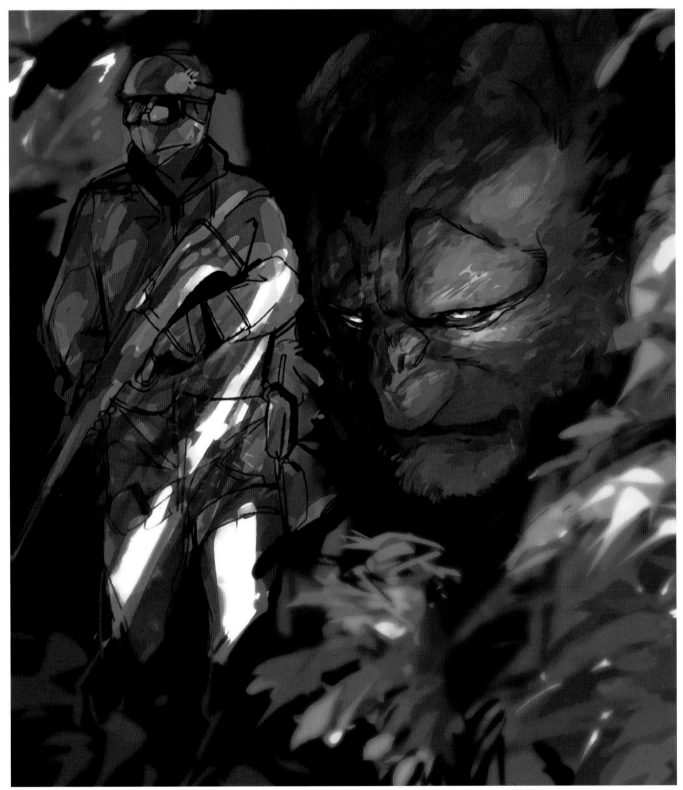

↑ The ratio of the human in the foreground to Ajai in the background increases its monstrous impression.

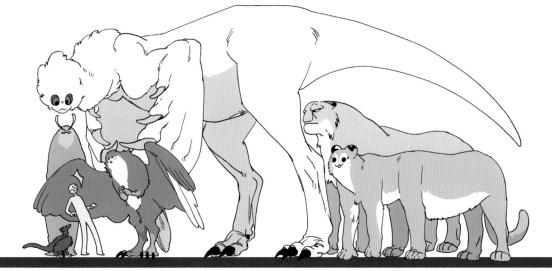

↑ The scale relationships become clear when characters are arranged side by side.

Depicting Character Scale Relationships

Just because the real-world inspiration is large or small doesn't mean you have to make your character that size too. Find the most appropriate size for your character living in the world you're trying to depict. The easiest and most objective way to express size is to place a human alongside your character to indicate scale.

From *Shinwa no Kemono*

Sumiyoshi's Sketch Notes (Dinosaurs and Reptiles)

Dinosaurs and reptiles are closely related to birds. They are more interesting to draw if you think about their behaviors, the climate they are (or were) accustomed to, the time in which they exist (or existed) and the ecosystem they inhabit (or inhabited). For dinosaurs, look into other close relatives in the phylogenic tree.

Sketching Dinosaurs

As fossilized bones, eggs and footprints are all we have to understand dinosaurs, there are many unknown elements for these creatures, including the color and texture of their skin, and body fat distribution. That makes it an attractive motif, being something that actually existed, but that also has a high degree of freedom of expression for drawing characters.

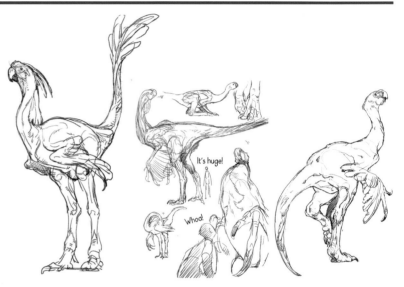

It's huge!

Whoa!

↑ The gigantoraptor, a 24-foot (8-meter) tall parrot-like dinosaur. As its head looked just like a macaw, I based it on that bird and drew it imagining the size and other elements.

← The gorgonops, a mammal-like reptile, existed before dinosaurs appeared and I love it because it has an indescribable quality to its appearance, as if it were still resolving its own form.

↑
Gorgonops

Recently I've been tinkering with the mosasaurus

Looks like a seal's flippers

Not many animals are 4 times the size of a T-Rex!

↑ The spinosaurus, which became well known due to *Jurassic Park III*, has recently been found to have had a different appearance. Every time a new discovery is made through research, we have to adjust how we depict their forms with our updated understanding.

Predator X

It's a logical progression for the new mosasaurus, but I also like how it incorporates the predator-like feel of a plesiosaurus, so I'm pleased.

← It's fun to draw forms that are hybrids between old and new species.

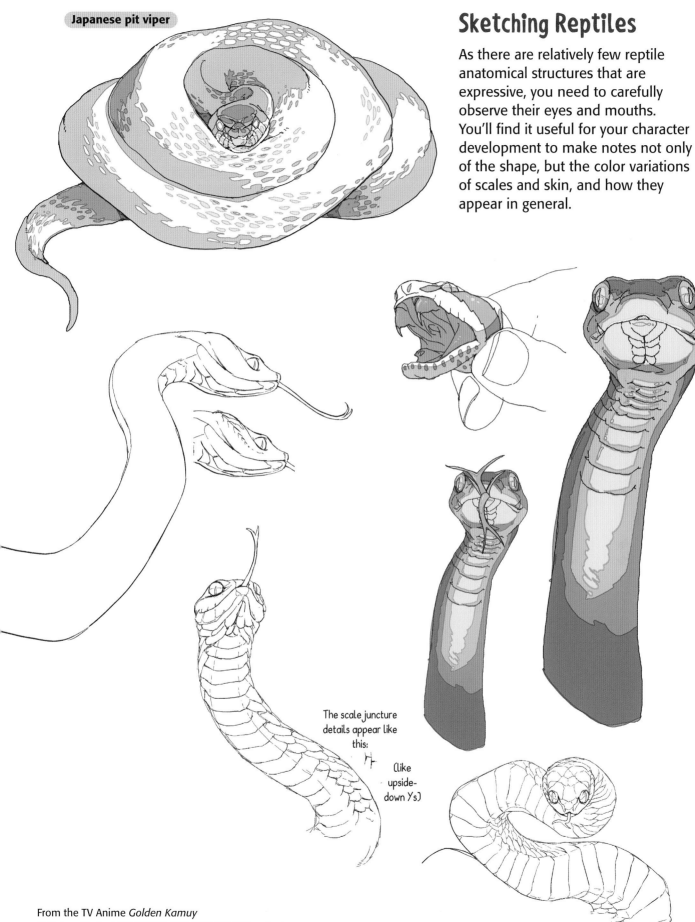

Japanese pit viper

Sketching Reptiles

As there are relatively few reptile anatomical structures that are expressive, you need to carefully observe their eyes and mouths. You'll find it useful for your character development to make notes not only of the shape, but the color variations of scales and skin, and how they appear in general.

The scale juncture details appear like this:

(like upside-down Ys)

From the TV Anime *Golden Kamuy*
© Satoru Noda / SHUEISHA, GOLDEN KAMUY project

Sketching Reptiles (Alligators and Turtles)

The skeletal structures of these animals are completely unique, so you can't use knowledge of mammals as a reference. There are some that bend their legs in unusual ways and others that stretch their necks, so it's important to actually study the anatomy. Don't try to just conjure up anatomical details with educated guesses from your imagination.

 These creatures have been living on this planet in these forms and with these skeletal structures much longer than humans have, so observe them while respecting their structures.

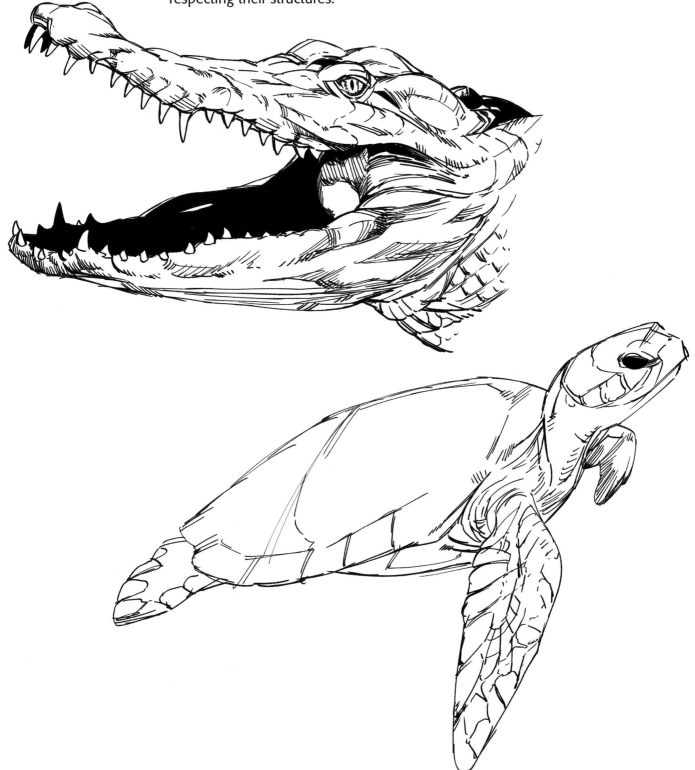

Anthropomorphized Arthropods

In this chapter, we'll look at anthropomorphized arthropods. While this is a motif I love, the fact of the matter is that many people feel disgust for them. So how should you design these characters so they can be widely accepted? Anthropomorphization makes it possible to shift impressions, so here you'll learn how to do that.

Think About the Balance of Attributes

The size and degree of anthropomorphism of a creature can greatly alter the impression it gives. So when you're deciding on the setting for a character, think not only about its shape and personality, but its size and "human-ness" too.

Arthropods are the type of creature that the more you know about them, the more fascinating they become. They make up the majority of life on Earth and, in a way, they direct the future of this planet.

As they are human-like, I added unique insect patterns like tattoos to their arms.

For each motif, I think about the percentage of arthropod elements I should include. So, for example, if I use "mechanical" (hardware) elements, I can keep the look of an insect, but it won't look as creepy as the biological equivalent.

Sergeant Ashidaka

Spider + Military

Spider + Steampunk

Changes When Using the Same Motif in Different Settings

Both of these characters use the same spider motif, but the backstory for the drawing I did initially (above) of Sergeant Ashidaka of the Anti-cockroach Forces and that for Ashidaka (right) that I redesigned for *The Iron Hero* (Kodansha) are different. I replaced 4 of the 8 limbs with mechanical ones, which helps dispel potential distaste for the joints and soft sections of insects (a lot of people don't like these aspects), while still allowing the limbs to be used for the same purpose.

Ways to Increase Acceptance

The easiest way to make the concept of insect characters more palatable is to simply make people feel more familiar with the character by emphasizing the anthropomorphism. Let's use a grasshopper as an example. I'll explain why I think this is important, despite insects being one of my favorite motifs.

↓ It's still an insect, but now it is bipedal.

(1) Human 0 : Insect 10

This is the insect in its natural state.

(2) Human 2 : Insect 8

Here the body is raised up. This is the stage where you can make very cool adjustments, such as emphasizing the joints and other features of the legs to create an insect-like giant (kaiju) or adding elements that incite fear to form a monster (kaibutsu).

← The impression of anthropomorphism is slightly stronger.

(3) Human 6 : Insect 4

While the number of limbs and other elements stay the same, most of the parts are now human. While there might not be any detailed depiction of insect joints, because the limbs are the same number and proportions, it still gives an insect-like feeling. By making either the human or insect element stronger, you can create a giant creature (kaiju) or monster (kaibutsu), and if you add the look of increased intelligence, it becomes a scheming kaijin.

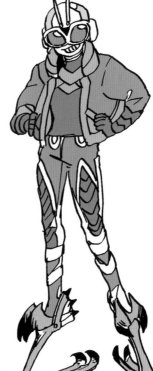

(4) Human 9 : Insect 1

The form and skeletal structure are almost completely human. Relevant thematic elements can be incorporated into your character's fashion, tools and accessories. I think anthropomorphism, as it is commonly regarded, is often expressed like this. It is probably the most sought-after form of anthropomorphism in terms of freelance illustration. If you pay attention to the color, clothing design and other elements, you can create a human-like character without losing the distinctiveness of the original insect. You can easily create variation by manipulating the outlines of fashion items, such as customizing footgear.

→ The curved lines across an insect's belly can be expressed through the pattern of the clothes, protectors, and other items.

Designing for Character Acceptance

When working with motifs that create feelings of disgust, you need to think of ways to make them more acceptable. But if you only focus on doing that, you start to lose your passion for the motifs, even if you found them to be fascinating at first. What points should you focus on to create expressions that make the most of your favorite parts? Here, I'll summarize ideas and tips on how to develop these expressions.

Dispelling Disgust isn't "Pleasing the Masses"

I feel compelled to give an explanation about minimizing unpalatable characteristics. This is to prepare yourself for the fact your character will likely be seen by many people. It also prevents it from being said that your favorite motifs are not good for business due to you having a lack of expressive range or ability.

Whether it be your drawing style or your power of expression, if you increase the level of detail you include, any motif can become a character you can use for work. Plus, if you always keep in mind that there are people who find the motif repulsive, you customize what you put down when drawing. This will increase the number of opportunities you have to draw, ultimately giving you the freedom to draw what you really want to and enabling you to reach the people who want to see it.

While it takes effort to get to the point where you can draw your favorite motifs without concern, the range of expression you have is a significant tool that can help you continue drawing until you reach that point. In other words, techniques for increasing an unpalatable subject's appeal are not for people-pleasing or giving in to popular sentiment under pressure, but rather it's another way of thinking so that you're able to work widely with your favorite motif. That's the way I'd like you to keep it in perspective.

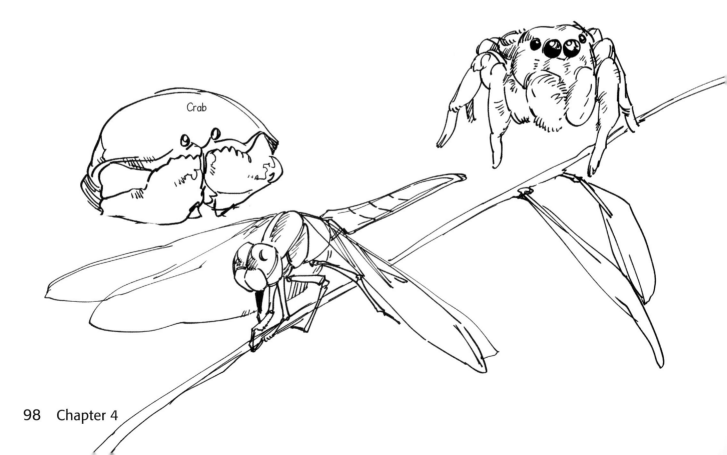

Crab

More Important than Appealing to the General Public

Make sure you don't try to align too much with what other people feel. You don't need to gauge their feelings. If you stop because people might not like it or don't draw something because it might unsettle them, your range of expression will shrink.

The most important thing is the amount of passion you feel when you want to express something you find cool, wonderful or beautiful.

Thinking something is cool will give you the power to think about how to draw it in a way that can be expressed to people, and it will lead to worthwhile trial and error that will broaden your range of expression.

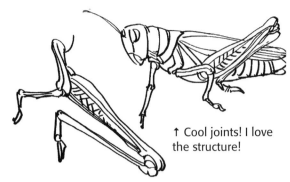

↑ Cool joints! I love the structure!

Getting a Better Understanding of People's Fears

It's important to understand "feelings" rather than "knowledge." As I mentioned in Chapter 1, people surprisingly can't fully envision subjects despite having general knowledge of them. Most of it comes down to feelings, emotions and impressions, so let's start by understanding and empathizing with the feeling of fear.

In my case, I was afraid of ghosts, while my teacher really disliked spiders. That teacher asked me if I would be able to remain calm if a ghostly shadow passed across one corner of a room and then quickly disappeared (like a spider). That's when I understood her point of view.

In other words, rather than showing something as it is because you're fine with it, try replacing your feelings for it with the fear of something you actively dislike. If you do that, you should be able to use that as a reference to devise a way to alleviate that fear.

Try replacing objects with what other people find as scary as the things you're afraid of.

I see!

What I find scary **What I'm fine with**

This is actually scary for me, so I can only draw ghosts that are not frightening!

The Power of Human Interest in Character Design

The reason I'm able to spend my life doing character design is because I can move past fear and disgust to convey interest and beauty through drawing individual characters. This is because it makes it possible to spark interest without triggering feelings of distaste.

When people become interested in a thing, an amazing thing happens—a level of acceptance occurs. Even if they don't come to love it, their feelings of aversion are reduced.

This approach at least dispels some of their fear or anxiety. I love being able to draw what I want to, so I want to continue designing characters in a way that conveys what's excellent and interesting about them.

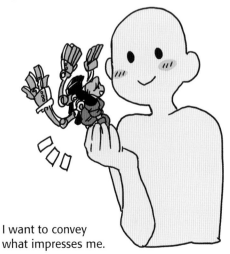

I want to convey what impresses me.

Anthropomorphized Arthropods 99

Anthropomorphizing Arthropods for Commercial Work
— A Look at the Manga *The Iron Hero*

The manga *The Iron Hero* (published by Kodansha) is a commercial work that features arthropods as the main characters. Let's look at elements that tend to be avoided in manga for a wide audience and how I replaced them with more attractive ones.

Transforming an Aversion to Spiders into Individuality

The main character, Ashidaka, is based on a huntsman spider (*ashidakagumo* in Japanese). It quickly approaches its prey, holds it down with its long legs, poisons it with its strong fangs, and then takes it back to a safe place to eat. So I decided to form his arms with dexterous hands that can grab and carry things. I converted a number of limbs into mechanical prosthetic arms, and shifted the predator/prey relationship to one of mechanical tinkering, involving a process dismantling prey, harvesting mechanical parts, and then using those parts as upgrades, to reduce the sense of horror.

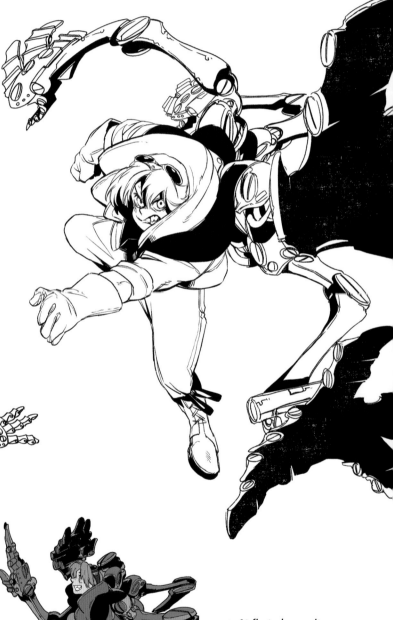

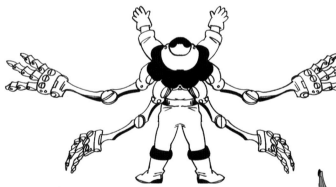

↑ In contrast, I kept the color scheme on the back closer to that of the original creature, so when spread out, the arms resemble the silhouette of a huntsman spider. Even with motifs that might be repulsive, if you can devise ways to make them only look that way when certain conditions are met, you can create more chances for people to appreciate them.

← At first glance, it just looks like a boy in steampunk attire carrying giant robot arms on his back.

Respect the Characters' World

In manga that features multiple characters, once you create one standard character, you can create the templates of the other characters based on the original. Here too, I was aiming to design figures that would fit the world the characters inhabit, while respecting the appeal of the original motif. I explain the concept of character development in more detail in the chapter on Anthropomorphized Birds and Reptiles (see page 62).

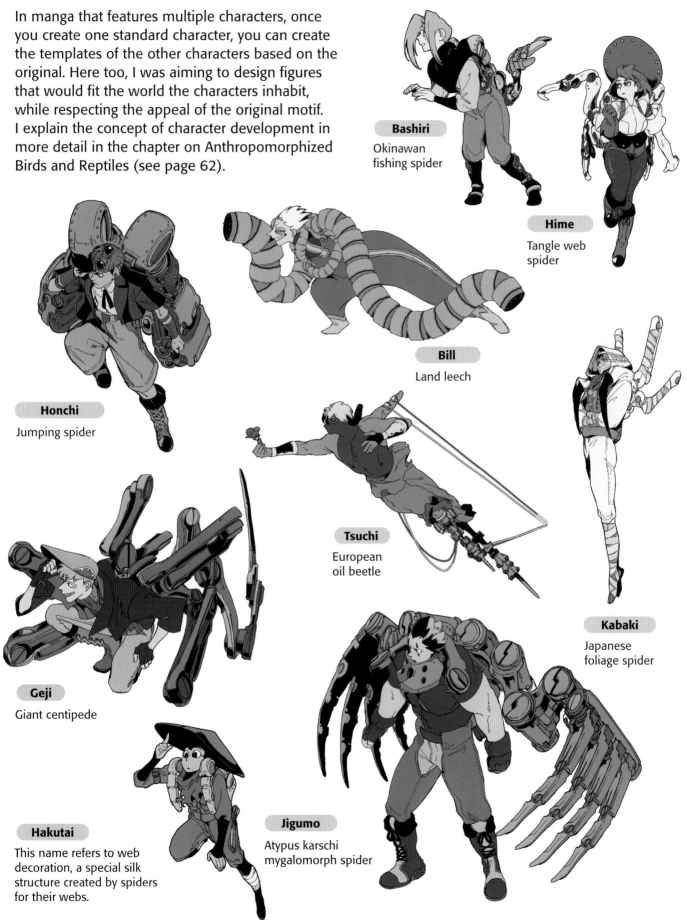

Bashiri

Okinawan fishing spider

Hime

Tangle web spider

Bill

Land leech

Honchi

Jumping spider

Tsuchi

European oil beetle

Kabaki

Japanese foliage spider

Geji

Giant centipede

Hakutai

This name refers to web decoration, a special silk structure created by spiders for their webs.

Jigumo

Atypus karschi mygalomorph spider

Initial sketches of the
Demon Dismantling Army

Stomp

Characters Aren't Made in a Day

If you can draw what is in your mind, you can specifically determine final elements, and also identify what you are missing. So, instead of trying to draw a finished character on your first attempt, start by drawing the image you have in mind, even if it is only vaguely defined. After that, you can make concrete improvements by seeing where you want to add something more this way, or make a modification that way, etc. Character sketches are very important for identifying areas in need of improvement.

Initial sketches for Ashidaka

Will they buy?

Welcome

Background characters are useful because they have a lot of freedom

Handy

Some wear clothes on their arms too

Stink bug

Background ① character idea

Gas

Arms have no power, so they wear gas cylinders on their back for fuel. This gas is very volatile.

↑ Sketches of a background character (see page 39). These are important because they represent the world they are in without the need for verbal explanation. Their appearances and gestures play an explanatory role, so I draw them carefully, even if they only appear in one frame of the story.

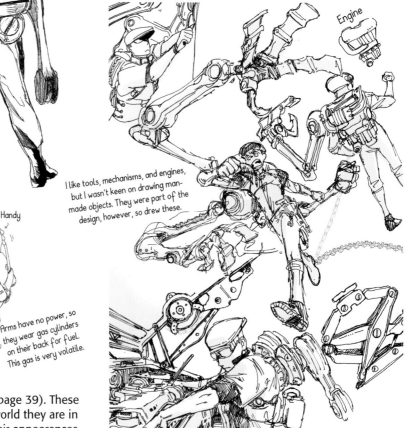

Engine

I like tools, mechanisms, and engines, but I wasn't keen on drawing man-made objects. They were part of the design, however, so drew these.

Sketches of gestures, actions, and how they move using their arms.

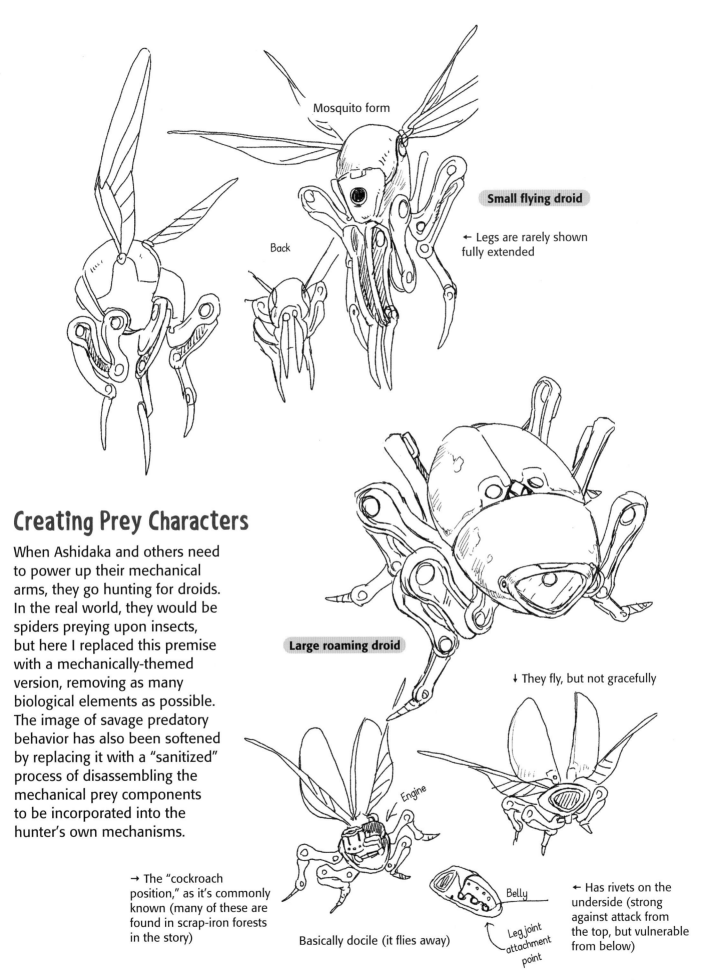

Mosquito form

Back

Small flying droid

← Legs are rarely shown fully extended

Creating Prey Characters

When Ashidaka and others need to power up their mechanical arms, they go hunting for droids. In the real world, they would be spiders preying upon insects, but here I replaced this premise with a mechanically-themed version, removing as many biological elements as possible. The image of savage predatory behavior has also been softened by replacing it with a "sanitized" process of disassembling the mechanical prey components to be incorporated into the hunter's own mechanisms.

Large roaming droid

↓ They fly, but not gracefully

Engine

→ The "cockroach position," as it's commonly known (many of these are found in scrap-iron forests in the story)

Basically docile (it flies away)

Belly

Leg joint attachment point

← Has rivets on the underside (strong against attack from the top, but vulnerable from below)

Anthropomorphizing Arthropods
(Drawing Monsters)
— A Look at the Manga *The Iron Hero*

In any story, there needs to be an antagonist for the main character. In the case of *The Iron Hero*, the giant tropical centipede is the strongest opponent. Here, I'll introduce its characteristics and the techniques I used to express its overwhelming presence and strength.

The Centipede

What are the Elements for an Arch Enemy?

This is the strongest predator that Ashidaka and his companions battle against in *The Iron Hero*. I wanted to create an enormous presence akin to a natural disaster, so I sought out a look that was distinct from other droids and created the impression that it had intelligence.

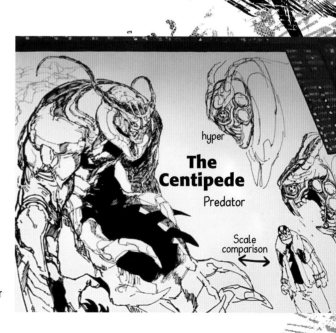

hyper

The Centipede
Predator

Scale comparison

Initial sketches for
The Centipede

The Iron Hero ©2008–2022 Kodansha Ltd

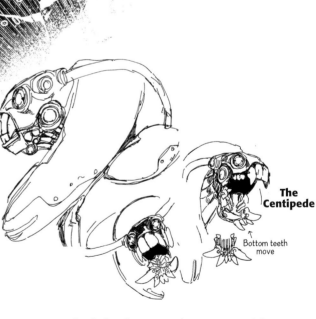

The Centipede

↑
Bottom teeth
move

That said, I didn't want to make it look too anthropomorphic. It was while I was thinking about making it animal-like yet with a will of its own that I was stung on my leg by a centipede that had crawled into my futon! Although I groaned at the intense pain, I also thought, "So this is the infamous sting of the centipede!" and I used that to guide me in my drawing, reflecting it for what it was. By the way, I've been stung by wasps and horseflies, but centipedes have a much more painful sting—and they come inside!

Creating a Different Character by Changing the Theme

You can use the same motif to create completely different characters by changing the setting and backstory. Here, I'll use examples from *Tennen Gaimushi Busters*, published before *The Iron Hero*, to show you how to have fun with application and variation.

Anthropomorphized Arthropods

The Iron Hero features characters based on anthropomorphized insects. These characters originally appeared in *Tennen Gaimushi Busters*. I got this idea from a cleaner who I hired to come over when I was super busy and my place was getting messy. He was surprised there were no flies, adding "It's thanks to the spiders." Initially, I combined the themes of cleaners and spiders (beneficial creatures), but later added military aspects to make them a fighting force. I depicted the relationship between predators and prey, focusing on the human concept of beneficial arthropods versus pests.

← I equipped them with goggles and hoods to keep a spider-like look.

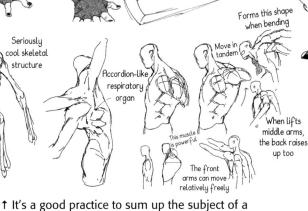

Completely different to a human form. More like the skeletal structure of a hand.

Seriously cool skeletal structure

Accordion-like respiratory organ

This muscle is powerful

The front arms can move relatively freely

Move in tandem

Forms this shape when bending

When lifts middle arms, the back raises up too

↑ It's a good practice to sum up the subject of a sketch with a single word or phrase for later reference.

As this character has a body with six arms, I invented the skeletal and muscular structure, as well as the construction of the clothes. And because the structure of real spiders can't be used as it is, I adopted the structures of other sources (such as human hands).

When making specific poses for your characters, think about how to make the silhouette resemble that of the original creature. Sketch the pose in alignment with the general body plan of its real-life counterpart. I narrowed down the motifs for predators (beneficial arthropods) to spiders and giant centipedes and from there thought about motifs for prey (pests).

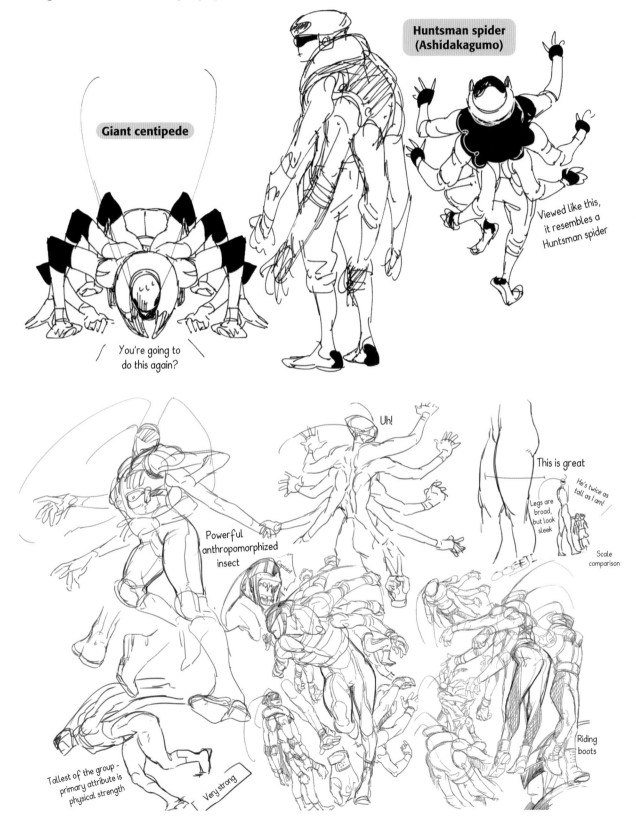

Giant centipede

Huntsman spider (Ashidakagumo)

Viewed like this, it resembles a Huntsman spider

You're going to do this again?

Powerful anthropomorphized insect

Uh!

This is great

He's twice as tall as I am!

Legs are broad, but look sleek

Scale comparison

Tallest of the group - primary attribute is physical strength

Very strong

Riding boots

Creating Arthropod Characters

I seem to have a talent for creating characters for whom many people have feelings of aversion. This is a skill I learned through trial and error, by teasing out attractive elements and determining what will be accepted and appreciating by the consumer.

A strong sense of texture gives the immediate sense of insect biology, so I adjusted the silhouette by creating feather-like volume to the antennae.

← The pale flesh tone is due to character's white-ish blood. This color gives a cool impression to an anthropomorphic character. I created an imposing towering pose to show that even with its head covered with a hood, it can see its surroundings.

Making Dislikable Things Look Cool

The first step in making something cool is to alter the perception of it being "creepy." The key is to emphasize the aspects that are awesome or cool.

You can then see what positive attributes can be linked to them too. For example, cockroaches are one of the most familiar living fossils, having a history of 300 million years. They are perceived negatively, but they have some amazing attributes:

- Runs at a maximum speed of 185 mph (300 km/h)
- Perceives space three-dimensionally using air flow rather than relying solely on vision
- Uses the faintest light to move through the dark

I combined this species' traits with ninja elements to convey the appeal of such an interesting living entity.

At first, I came up with this design. A lot of people told me "It's cool, but it looks like a cockroach," and I had to agree. It's most likely the long antennae that make it appear that way. I replaced the volume of the cockroach's soft wings with antennae and incorporated the overall silhouette into fashionable attire to reduce the unsettling aspects. You need to decide which points can be altered and which should be left as they are. It's important to be willing to make drastic alterations as you refine the details of your character's design.

Scythe Master

Lady Mantis

Merits of Anthropomorphism

If someone hates something, even just the silhouette is too much. There are some people who can't even hold an insecticide spray can because of the pictures on it. By anthropomorphizing insects though, you can convey their way of life in an interesting and cool way, even to people who don't like them. In the past, I drew a manga about why cockroaches dare to come toward insecticide spray and people who couldn't even look at the real thing thanked me for depicting roaches as sympathetic characters. It was an unexpectedly rewarding experience.

Relative

It's true

The Cockroach and Praying Mantis are Closely Related

Anthropomorphizing Beneficial and Detrimental Insects

In anthropomorphism, it's popular to use the technique of reflecting the real-life creature's physical attributes in the character's attire. It can be instantly recognized if the character's look matches the appearance of the original organism.

Expressing Elements through Attire

I designed the spiders and cockroaches I mentioned before by envisioning them being indoors, so I decided to make this an insect that's commonly seen outdoors. Bees sting, and that sting is venomous, but they are also regarded as beneficial insects that (among other things) reduce the caterpillar population. Caterpillars are pests when it comes to horticulture and plant cultivation. That's why I decided to make the queen a beneficial insect and gave her a fishtail-style dress to accentuate her impressively narrow waist.

↑ Bees are closely related to ants. Here, I've lined up a black ant character next to a bee character.

The queen's partner—a cabbage white butterfly. This butterfly is an attractive-looking non-poisonous creature. As it's an antagonist to the queen, I made it look like a duke.

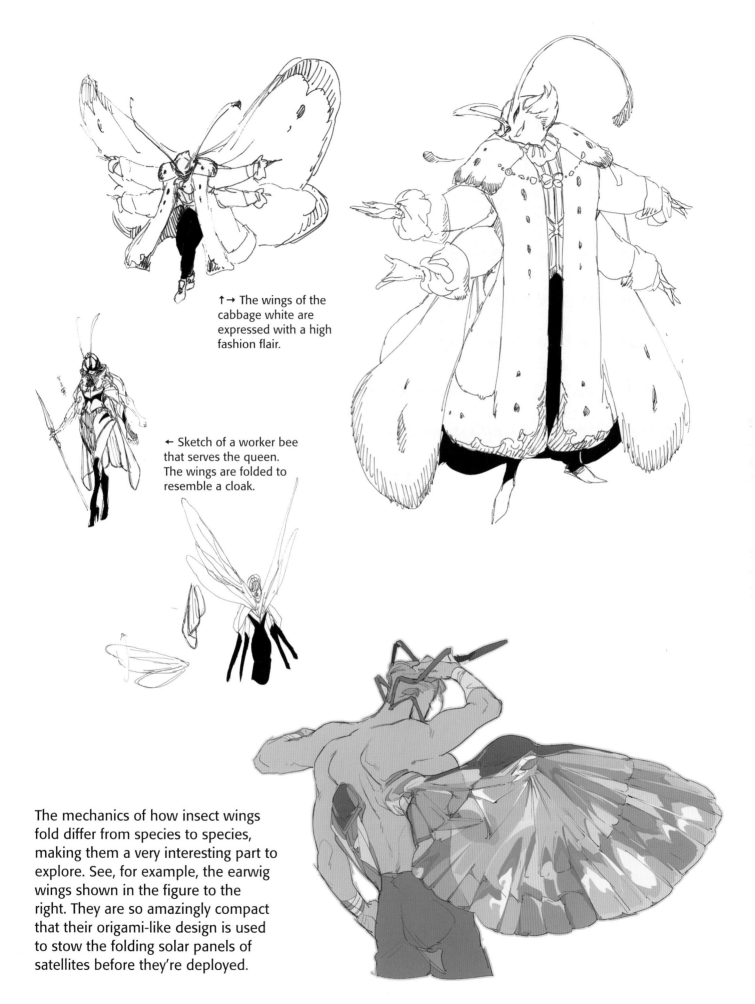

↑→ The wings of the cabbage white are expressed with a high fashion flair.

← Sketch of a worker bee that serves the queen. The wings are folded to resemble a cloak.

The mechanics of how insect wings fold differ from species to species, making them a very interesting part to explore. See, for example, the earwig wings shown in the figure to the right. They are so amazingly compact that their origami-like design is used to stow the folding solar panels of satellites before they're deployed.

Creating Crustacean Characters
(Drawing Non-human Entities)

With crustaceans, you can't get away with just making up their structure from imagination, so the key to turning them into characters is learning how to simplify their complex structures. Let's take the crab as an example and see how we can make it look like a character from a story.

This character, Kaninja, includes elements of a crab and a ninja, both of whom are good at walking sideways without a sound and hiding in tight spots. The reputation the ninja have of not showing their faces and operating in silence creates the impression of a *kaijin*-like monster. The human element is mainly the "seeing eyes." For creatures that have a lot of complex parts, you can omit the details or use solid color at the back to make the important parts in the foreground stand out, while still keeping the same general amount of visual information.

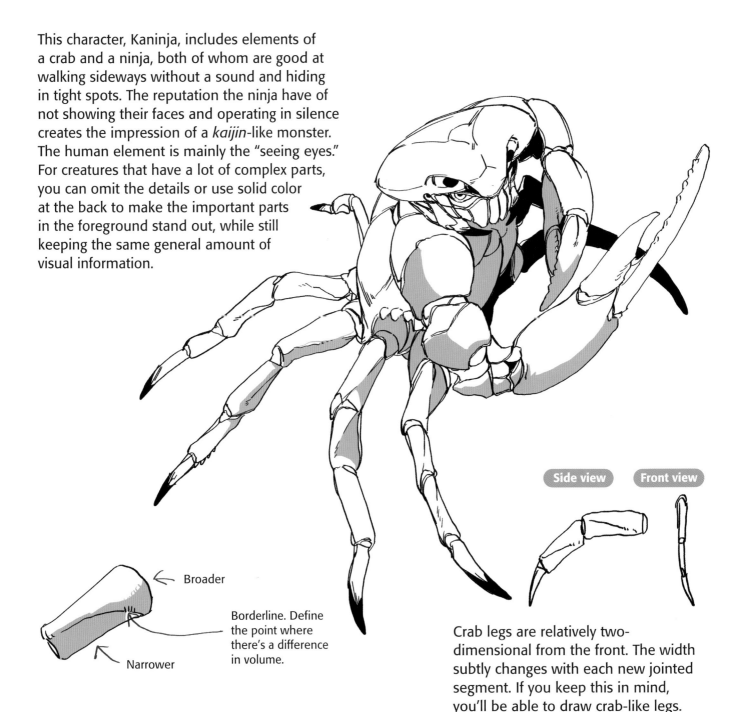

Side view Front view

← Broader

Borderline. Define the point where there's a difference in volume.

Narrower

Crab legs are relatively two-dimensional from the front. The width subtly changes with each new jointed segment. If you keep this in mind, you'll be able to draw crab-like legs.

Create a Library of Sketches Depicting Movements and Forms

This drawing is quite old and I only had rough sketches remaining, which I've cleaned up here. I didn't include any details in the rough sketches and instead tried to get a general idea of balance and placement. These types of sketches are fine as long as you have an idea of the shape, so make a lot of drawings from all angles, as well as of various movements. This will create a good stock of ideas for you.

When it sees something of interest, the eye stalks in its helmet rise.

Sideways movement

Thinking of Anthropomorphic Characters Based on Arthropods

Here's an example of a *kaijin* based on an arthropod, which is a common motif in popular stories. Arthropods are visually-rich inspiration, so it's important to emphasize or omit details accurately and decisively. I'll also show you how to examine the silhouette from two angles—the front and side.

Arthropod-like features can be depicted through the hardness of joints, spines and the shell, rather than through other details.

Focus on one major point and make the rest of the silhouette subtler to further emphasize the parts you want to stand out.

The key to creating a *kaijin* monster-like character is to use human body proportions and have horns and spikes growing out at the edges and on the back to give an aggressive impression.

If you give an insect-like impression at the joints and at the edges, you don't have to faithfully depict all of the details to give the impression of an arthropod. Solid black is also useful for manga. Just a strong silhouette alone is enough to make an impact.

For parts that don't move much, make them rigid so that they don't look out of place. Western armor can be a useful reference.

With more moveable and flexible parts, use fine overlapping scales and plates.

Think About Silhouettes from Two Angles

This is a technique I often used when designing for *Monster Hunter*. I drew reference lines across the most prominent parts of the front-facing drawing, including the joints and segments, and the ground. I then used those lines to draw a side view of the figure. The key point is to show the contrast between the front and side views, rather than matching the proportions exactly. If you have 3D modeling software, you can make a simple model to help you do this effectively.

Powerful creatures have large, broad muscles that stretch from the neck to the shoulders. If you try imagining something like a buffalo, it's easy to visualize this. If you keep in mind a silhouette with an arched back, you can create an impression of power even if parts of the anatomy are relatively thin.

Anthropomorphizing Crustaceans
(Drawing Monsters)

This character is based on the peacock mantis shrimp. I've applied techniques that I've used in the past throughout this process, including strategies to keep the long body from becoming too elongated and adjusted the sense of volume for certain parts.

Combining a Peacock Mantis Shrimp with a Dragon

I created this character, Monohana Shako Ryu, based on a peacock mantis shrimp. When creating a monster that borrows from real-life organisms for inspiration, it's a good idea to first determine which parts and elements will form the essence of the monster.

As with the key colors mentioned in the section on mammals (see page 33), you can spread out characteristic parts to create a cohesive impression. In this case, I added shiny parts to the area that corresponds to the eyes of the peacock mantis shrimp, but because this seemed to make the head alone look separate and because it looked just like a shrimp, I echoed the same feature on the body as well. This meant I could create a sense of unity for it as a living organism, while avoiding having the body look too long.

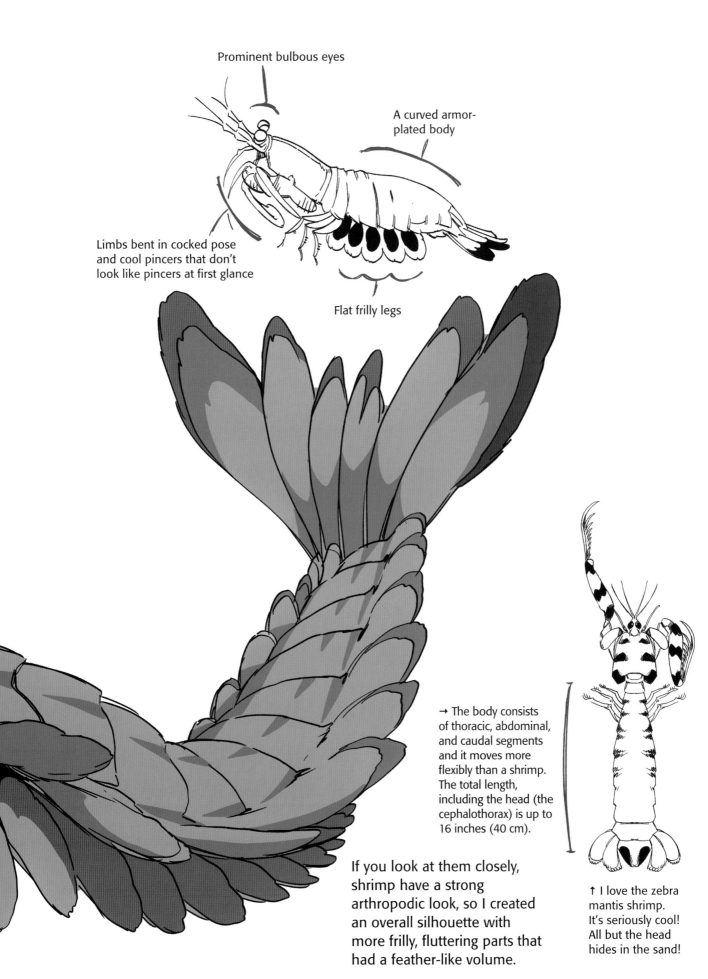

Prominent bulbous eyes

A curved armor-plated body

Limbs bent in cocked pose and cool pincers that don't look like pincers at first glance

Flat frilly legs

→ The body consists of thoracic, abdominal, and caudal segments and it moves more flexibly than a shrimp. The total length, including the head (the cephalothorax) is up to 16 inches (40 cm).

If you look at them closely, shrimp have a strong arthropodic look, so I created an overall silhouette with more frilly, fluttering parts that had a feather-like volume.

↑ I love the zebra mantis shrimp. It's seriously cool! All but the head hides in the sand!

Anthropomorphized Arthropods 117

Sumiyoshi's Sketch Notes
(Insects)

It can be difficult to observe insects with all their various moving parts. Discovering subtle differences in things like their leg structure, back shape, and texture will create more interesting character drawings.

Face

Scarab beetle

Plop!

Twitch

Rustle

Sketching Insects (Scarab and Stag Beetles)

These are sketches of a scarab beetle for the TV anime *Golden Kamuy*. I prepared two types—the earth-boring dung beetle and a more common species of scarab beetle. There is a huge range of species, so when you take on work, make sure to confirm beforehand exactly which species is required.

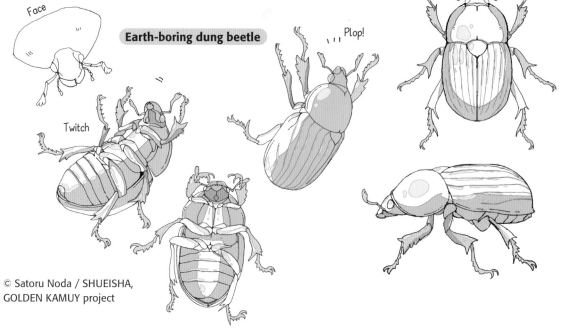

Face

Earth-boring dung beetle

Plop!

Twitch

© Satoru Noda / SHUEISHA, GOLDEN KAMUY project

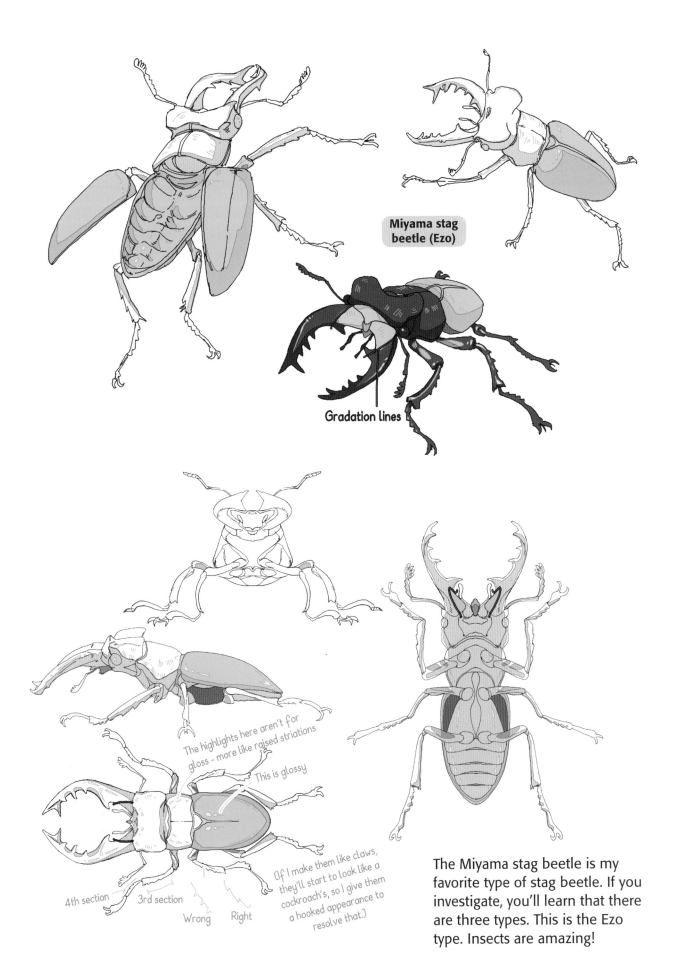

Miyama stag beetle (Ezo)

Gradation lines

The highlights here aren't for gloss - more like raised striations

This is glossy

4th section 3rd section

Wrong Right

(If I make them like claws, they'll start to look like a cockroach's, so I give them a hooked appearance to resolve that.)

The Miyama stag beetle is my favorite type of stag beetle. If you investigate, you'll learn that there are three types. This is the Ezo type. Insects are amazing!

Sumiyoshi's Sketch Notes
(Arthropods)

These are sketches of insects that some people don't dare to look at close up (because they're creepy), and of crustaceans for which there are surprisingly few chances to observe them. If you look closely at their structures, it makes it easier to alter them to be more mechanical.

Sketching Arthropods (Land / Sea)

When drawing arthropods, I always feel like I'm drawing plants.

→ If you look at just the face, the German cockroach is actually quite handsome. It's so good-looking that in a contest to choose the coolest insect face—without revealing the names of those insects—it got high scores. But the moment people found out it was a cockroach, it was dropped from the ranking, and so I admire the face of this maligned insect.

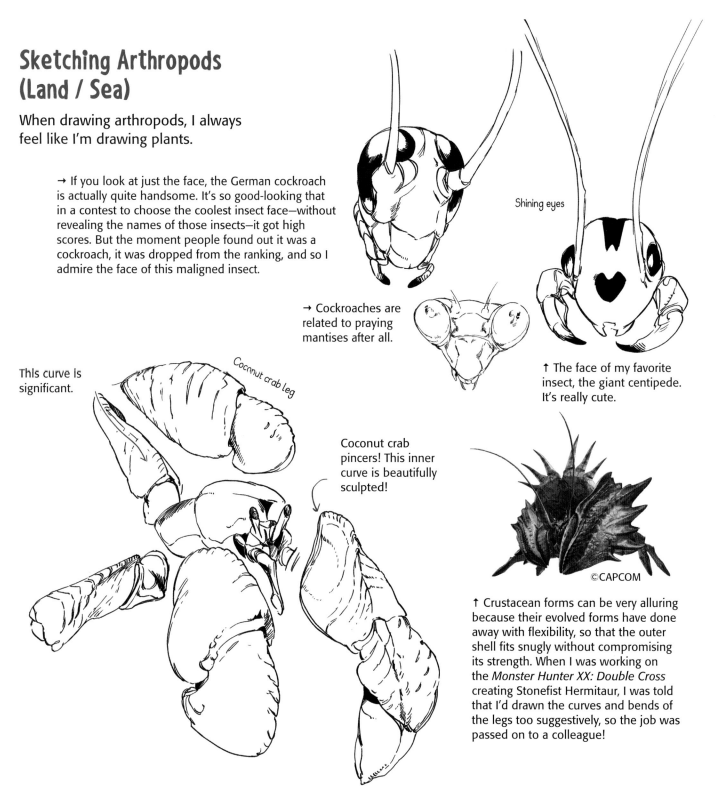

Shining eyes

→ Cockroaches are related to praying mantises after all.

↑ The face of my favorite insect, the giant centipede. It's really cute.

This curve is significant.

Coconut crab leg

Coconut crab pincers! This inner curve is beautifully sculpted!

©CAPCOM

↑ Crustacean forms can be very alluring because their evolved forms have done away with flexibility, so that the outer shell fits snugly without compromising its strength. When I was working on the *Monster Hunter XX: Double Cross* creating Stonefist Hermitaur, I was told that I'd drawn the curves and bends of the legs too suggestively, so the job was passed on to a colleague!

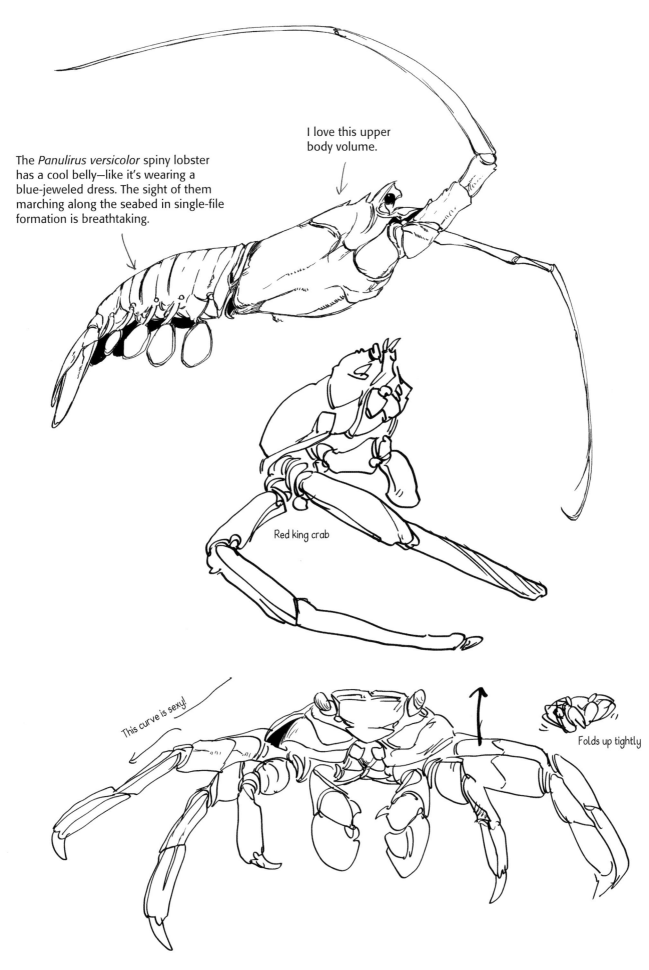

The *Panulirus versicolor* spiny lobster has a cool belly—like it's wearing a blue-jeweled dress. The sight of them marching along the seabed in single-file formation is breathtaking.

I love this upper body volume.

Red king crab

This curve is sexy!

Folds up tightly

Enjoy Anthropomorphizing Intangible Feelings and Concepts

This book explains techniques for anthropomorphizing living things, but they can also be used to anthropomorphize intangible things like natural phenomena, sensations, concepts and other things with no form. There are various reasons for anthropomorphizing things, and there are many times when I employ these techniques to personify something I don't like.

→ *Harusaki Kanpa Sankyōdai* is an example of the bitterly cold spring weather being anthropomorphized. I live in Nara, Japan now, which gets really cold, so I started thinking about how to put that sensation of the cold into some kind of physical form. In February, it feels like a sharp stabbing, in March it feels like if you're not careful, you'll get beaten up, and in April, the cold at night is like being suddenly slashed by a sword. I drew these as personality traits. I thought this would help me convince myself that "there's nothing that can be done because they're here" or to make me feel as if "I'm going to drive them back." These are characters I drew for myself so that I could have some fun while facing the pain.

← These are bomb cyclones personified. I get migraines due to changes in the barometric pressure, and when they are really bad, I can't even get out of bed. I drew these characters as something beyond human existence, so that even in painful times, I can think, "if these bad guys are coming down here, there's nothing I can do." They are like conductors bringing in heavy rain and thunder clouds using a thunderbolt-like hammer and I call them the "Low Pressure Brothers."

Whenever I draw these entities, I'm reminded that Japanese people's sensibilities have probably not changed since ancient times. The desire to overcome the harsh realities of life by pushing back against nature and trying to grasp a sense of reality in a relatable way may have been one of the reasons for the creation of yōkai and other forms of Japanese monsters.

CHAPTER **5**
Anthropomorphized Fish

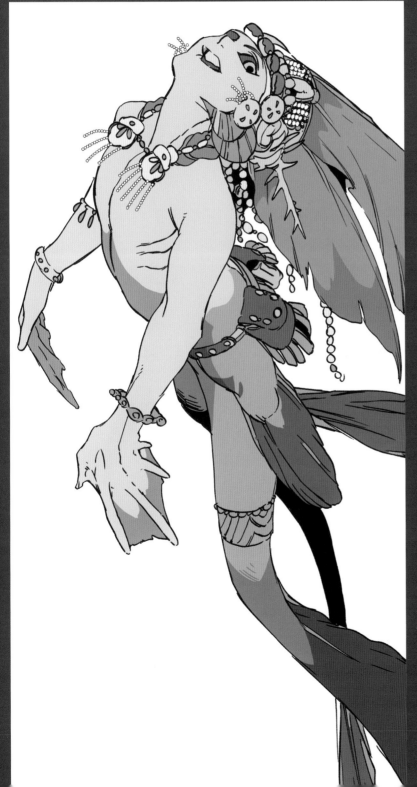

In this chapter, we look at anthropomorphizing fish. The most representative entity for this has to be merfolk, who are legendary worldwide. There are a wide number of variations that can be created—from cute designs, like those found in anime and fairy tales, to strikingly-fierce human-faced fish.

Creating Fish Characters—Part I
(Drawing Human-faced Fish)

These characters are fish with human faces. The fish aspect is often emphasized, but you can create a feeling of familiarity by adding human elements and creating entertaining scenarios.

This is regarded as a merperson, but the character gives the strong impression of a human-faced fish. I created it so that, at first glance, it gives the impression of being large, heavy and solid, like a goliath tigerfish, while also incorporating a surprisingly athletic form.

↓→ The head is small and flat from the forehead to the nose, which increases the length of the neck and expresses that it has a muscular build.

← It may look ferocious, but because this is an ambush predator that only eats fish small enough to fit in its mouth, it can mingle with other larger fish without causing alarm.

If you add a shadow that hugs the body, you can express the swell of the abdomen.

The Payara (*Hydrolycus scomberoides*) is a well-known species of fanged fish. It looks like it should be fast, but it's not as a good a swimmer as the goliath tigerfish and it's also an ambush predator. I based the original on a handsome man, so I tried giving it the look of a leopard seal. I also brought the pectoral fins (analogous to human arms) over to the chest, keeping their form the same, to give a sensual image that is not overtly sexy.

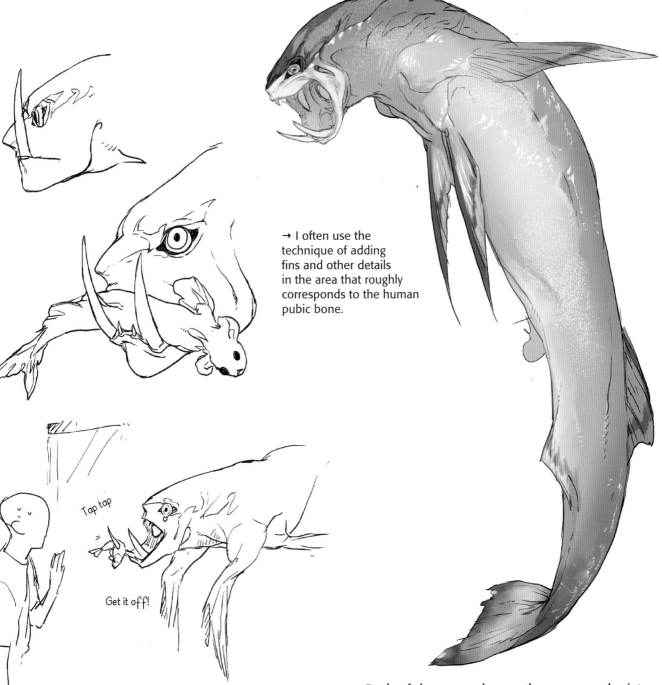

→ I often use the technique of adding fins and other details in the area that roughly corresponds to the human pubic bone.

Tap tap

Get it off!

↑ Just because it looks terrifyingly stern, it doesn't mean it's violent. I'll come up with some entertaining scenes too, to reflect its life as an individual living organism.

Both of the examples on these pages depict very large fish. I like to draw fish and other animals that are bigger than humans.

Creating Fish Characters—Part II
(Drawing Merfolk)

Here, I'll give some examples of merfolk with additional elements that transform humans into fish and incorporate unexpected motifs. Even merfolk that feel familiar can be given strong originality by combining a few unusual elements.

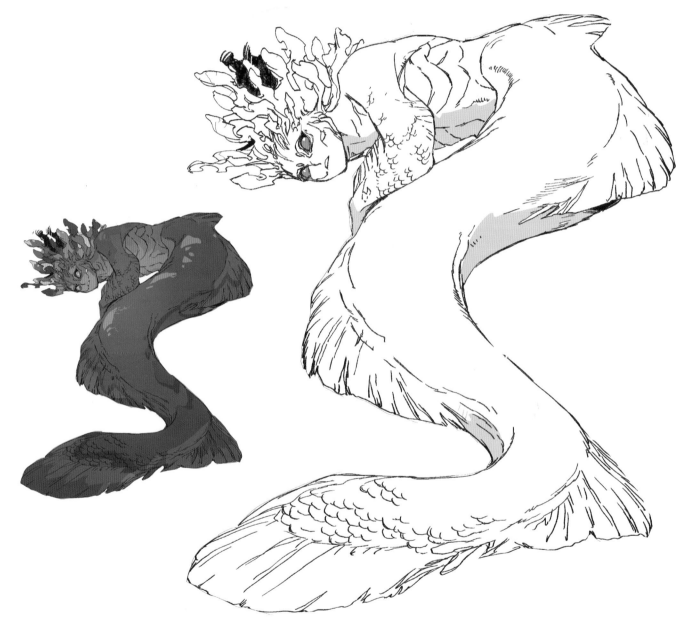

Using Ancient Fish as a Motif

The backstory here is that a researcher has transformed from a human into a merperson. This image combines the aquatic plant-like fins of the leafy seadragon with the ancient fish *bichir*. It lays in wait for prey among the swaying giant kelp, which it mimics. As I imagined and drew the idea that became this example, I also visualized its way of life. Thinking about a character's habitat makes it easier to find points to improve, like its color, fins and body length.

Think About the Transformation Process

This is a completely different life form to a mammal, so the way its skeletal structure changes has to be established too. Here, I decided the flesh and bones under the human skin would melt to mush and when it was ready to become a merperson, it would tear open the skin and emerge—just like a caterpillar becoming a butterfly. Specifically, the lower half of the body changes first to form external gills like those of an axolotl, and then while the lower body is submerged in water, the upper body starts to transform until it becomes a complete merperson.

← Axolotl is the familiar name for a type of salamander that retains its juvenile form (*neoteny*). While most salamanders have external gills as juveniles and lungs as adults, this species retains its gills right through to adulthood.

→ It has closely packed teeth in its mouth. It swallows food whole.

I consistently draw like this so I can end up with a satisfying form. I can't draw something without knowing it well, so even when I'm drawing freely, I stay within a prescribed range. I think I make a lot of sketches of the process and progress so that I can define those limits.

Anthropomorphized Fish 127

Synthesizing Disparate Ideas

While I was looking at African beaded ornaments for inspiration, I was reminded of Native American decorative headdresses made with feathers. But if the headdresses were comprised entirely of beads, it would be too heavy to wear—but not underwater! I wondered what it would be like to draw a merperson like a Native American with hair decorations made completely from seashells. This is where my thought process started.

Ideas and inspiration can often suddenly connect. Even things that seem disparate can lead to being able to view or understand something in a novel way.

If you can develop that kind of flexible thinking and creativity, you will be able to use everything in the world as inspiration!

All the decorative items are seashells. The parts like feathers are the fins of the Indo-Pacific sailfish that I've adapted.

If you make items wavy, they will appear to be floating. Adding gentle undulation is effective for heavy-looking things.

Two eel-like tail fins give the impression of legs.

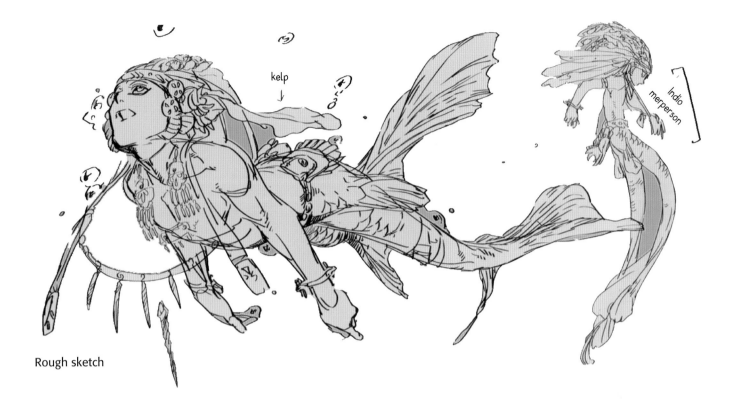

kelp

Indio merperson

Rough sketch

The rough sketches on this page are ones I did when I was around twenty years old. Those on the facing page are more refined sketches I did for this book after I turned thirty. I also found a rough sketch of the character riding a horse made from waves and foam (below). Even when I see it now, I think it looks cool. If you're always pursuing different ideas this way and save a lot of your work, it will serve as inspiration for years to come.

Continuing to regularly pursue and draw what you love will also help you appreciate the things you enjoyed and loved so much in years gone by. If you concern yourself only with how people see you, your popularity and the quantity of work that you output, at some point you may run out of new ideas. But even if that happens, keep drawing what you like, or what sparks your interest, and the characters you have drawn in the past are sure to inspire you going forward. That's why it's important to keep pursuing whatever topics you're interested in.

Rough sketches

Sumiyoshi's Sketch Notes (Fish)

These are sketches I made of fish, focusing on sharks. The spare use of lines, the sense of volume, the way the fins and body connect, and the mouths are interesting, and I've drawn in a lot of detail. Please use these as reference along with the notes.

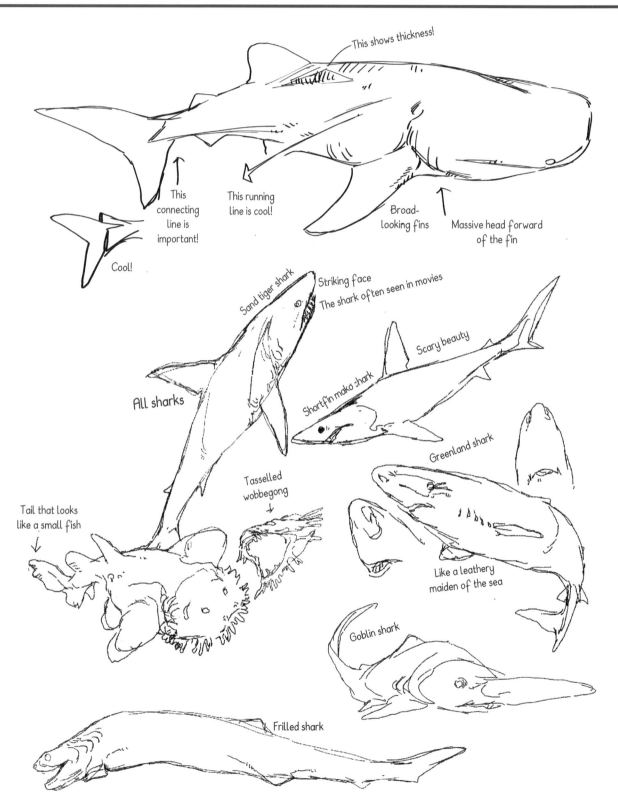

This shows thickness!

This connecting line is important!

This running line is cool!

Broad-looking fins

Massive head forward of the fin

Cool!

Sand tiger shark

Striking face
The shark often seen in movies

Scary beauty

Shortfin mako shark

Greenland shark

All sharks

Tasselled wobbegong

Like a leathery maiden of the sea

Tail that looks like a small fish

Goblin shark

Frilled shark

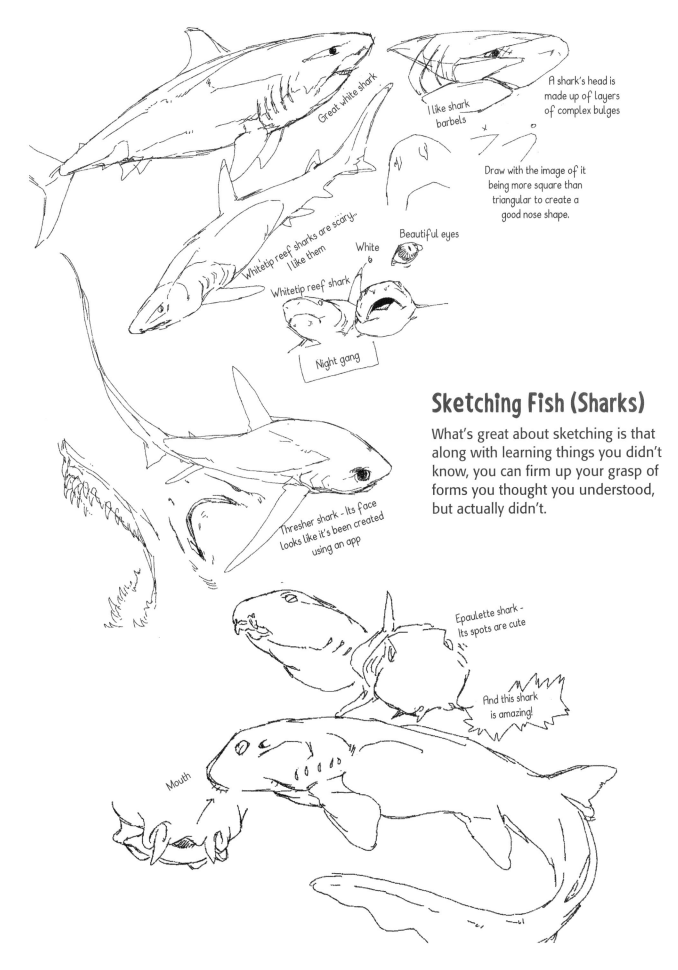

Great white shark

I like shark barbels

A shark's head is made up of layers of complex bulges

Draw with the image of it being more square than triangular to create a good nose shape.

Whitetip reef sharks are scary... I like them

White

Beautiful eyes

Whitetip reef shark

Night gang

Sketching Fish (Sharks)

What's great about sketching is that along with learning things you didn't know, you can firm up your grasp of forms you thought you understood, but actually didn't.

Thresher shark - Its face looks like it's been created using an app

Epaulette shark - Its spots are cute

And this shark is amazing!

Mouth

Thorough Sketching of Parts that Catch Your Attention

That fish mouth is interesting! That got me sketching the head, starting from the mouth. I do this for work when required, but I find myself exploring the parts that I like further, on my own.

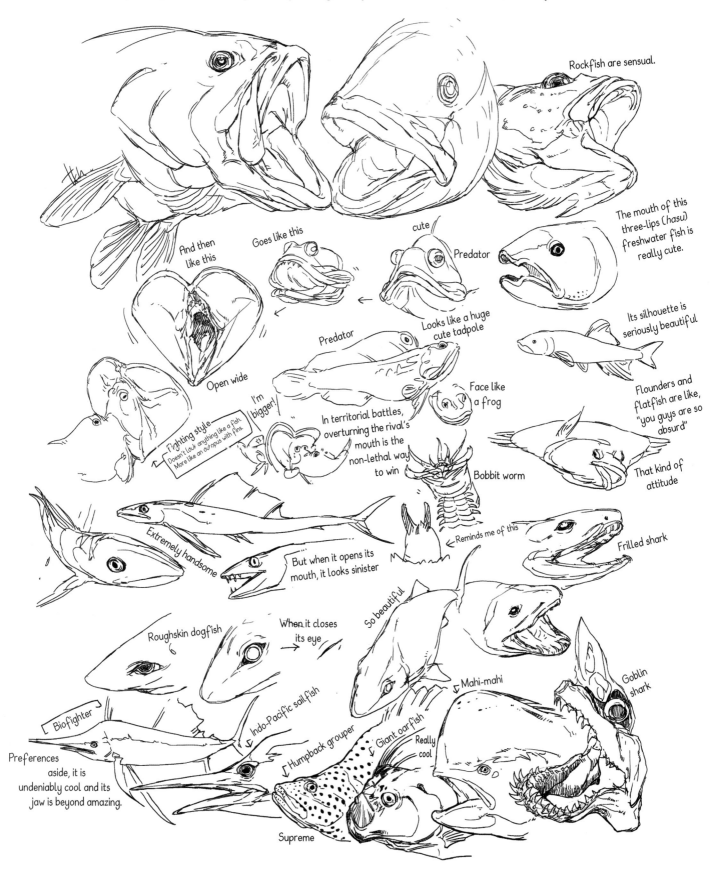

Rockfish are sensual.

The mouth of this three-lips (hasu) freshwater fish is really cute.

And then like this

Goes like this

cute

Predator

Looks like a huge cute tadpole

Its silhouette is seriously beautiful

Open wide

Predator

Face like a frog

Flounders and flatfish are like, "you guys are so absurd"

Fighting style... Doesn't look anything like a fish. More like an octopus with fins.

I'm bigger!

In territorial battles, overturning the rival's mouth is the non-lethal way to win

Bobbit worm

That kind of attitude

Extremely handsome

But when it opens its mouth, it looks sinister

← Reminds me of this

Frilled shark

Roughskin dogfish

When it closes its eye

So beautiful

Mahi-mahi

Goblin shark

Biofighter

Indo-Pacific sailfish

Humpback grouper

Giant oarfish

Really cool

Preferences aside, it is undeniably cool and its jaw is beyond amazing.

Supreme

Ryo Sumiyoshi's
Creative Environment and Process

The final part of this book gives you a peek at my creative environment. I'll describe what kind of setup I have and my creative process. I'll include some tips on choosing digital tools too.

Creative Environment

I used to do ink drawings, so I move my arms a lot as I create my work. That's why I use a WACOM 27-inch LCD tablet, because I'm not good at drawing in tiny strokes using small wrist movements. I like to hole up at home and work, so the area around my computer is well-equipped.

Wacom Cintiq 27

I spend 16 hours a day sitting in front of my PC and recently my knees have reached their limit.

Match your tools to your habits

↑ For people who want to have an analog feeling when drawing, or use flicks of the wrist, or draw small and compactly, I recommend the small LCD tablet on the right (you can draw directly on the screen).

↑ For people who feel their hands get in the way when drawing directly on the LCD screen or who want to use the screen in a wider way and have multiple windows open, try the tablet on the right (you connect it to a PC and what you draw is reflected on the monitor).

The application I use is CLIP STUDIO PAINT EX (known in Japan as "Kurisuta"), developed by Celsys. I used to use software like Corel Painter, Adobe Photoshop, and Paint Tool SAI, but now that I mainly focus on creating manga, I only use Kurisuta. When drawing completely digitally, it's easy to insert and remove lines and you can feel confident as it's from a well-established developer that provides excellent support.

By the way, WACOM is also a renowned manufacturer of LCD tablets and I choose their products because I don't need to worry about them going under and suspending support. If you're planning to work professionally, it's worth it to invest in your tools. When you do, I recommend you choose a manufacturer that is reliable and has an excellent warranty.

I love Kurisuta so much that sometimes I send love letters to the support center saying "Kurisuta is wonderful!"

How to Draw Characters

This is my regular creation process. I don't do anything really unusual and don't use more layers than necessary, so when you look at this, it may seem quite simple.

(1) Draw the line art

When creating this, use the reference layer for the line art.

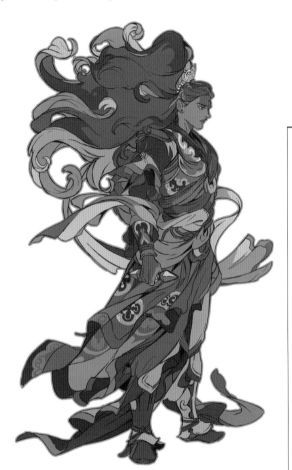

↑ I'm drawing this character.

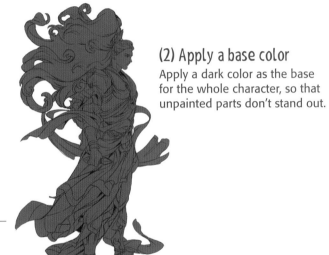

(2) Apply a base color

Apply a dark color as the base for the whole character, so that unpainted parts don't stand out.

(3) Add color

Add one more layer, set the Fill tool to fill in only that reference layer, and add each color. The illustration to the left is about 80% complete.

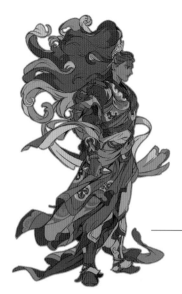

(4) Add shadow

Light is shining from below, so add shadow to the top areas to create shading. Add border lines to the base color from step 2.

Shadow colors

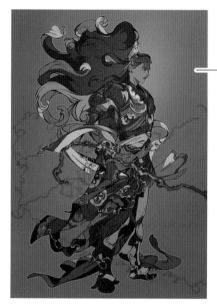

(5) Add brightness and depth

Using overlay with a 60% opacity, add yellowish color to the parts you want to brighten and purplish color to the parts you want to appear to recede. Then add a background color along with visual effects.

↑ Bright areas ↑ Dark areas

(6) Create a background

Add a black backdrop and make the lightning effects glow to complete the art.

The World of Manga and Anthropomorphic Characters that Sparked a Life of Drawing

Sumiyoshi started his career as a game character designer and has long been involved in various forms of independent production. After becoming a freelancer, he turned to manga.

Ryo Sumiyoshi

Sadness and Regret at the Inability to Convey Thoughts was a Driving Force for Drawing

■ **How old were you when you started drawing?**
RS I don't remember well, but I think I was already drawing when I was 3 years old. I wasn't good at speaking as a child, so this was the best way to convey my thoughts. My parents thought they were strange pictures and only my grandmother understood "you're a child who can draw your own feelings." The happiness I felt at knowing I could convey my feelings and that it was fine to do it that way, along with the enjoyment I got from drawing, were my main catalysts.

■ **When did you start drawing pictures to communicate?**
RS When I was 5. I was really impressed by the picture of a sperm whale I saw in an animal encyclopedia. In kindergarten, when I drew a scene from the picture book *The Greatest Treasure* about a flying whale, I was the only one who drew a sperm whale in the deep sea. But children don't have a lot of acceptance for things they don't know, so everyone said "That's not a whale, it's a monster!"

No matter how much I explained, I couldn't even get the teacher to accept it and it was the first time I cried due to frustration and resentment. I felt really bad for not being able to convey the magnificence of the sperm whale that had impressed me so much and because my drawing was so bad, even the animal I was trying to draw was ridiculed! I still feel angry and frustrated when I think about it now, but that's when I started consciously sketching as I felt if I couldn't draw something I was satisfied with, it couldn't be communicated to other people.

■ **What kind of things did you sketch?**
RS I just randomly searched for things around me. Unlike pushy, judgemental people, natural objects could sit quietly in acceptance of me for hours! At the time, I mostly drew leaves, stones and water, enlarging the parts that I was really interested in, so if you glanced at my pictures you wouldn't be able to understand a lot of them. Now I mainly draw animals, but the fact is I'm not really an animal lover. They are interesting, of course, but I regard them as just one of many natural objects. My parents loved the outdoors, so they took me all over the place, but even if we went to the sea or snowy mountains, I always kept a sketchbook with me, and even now whenever I go out I carry one along with a pen.

■ **Your frustration led to observing and drawing?**
RS Yes. But it was more that I was convinced that as long as I could draw something convincing that would make people say it is cool—whether it is fictional or a real creature—I could silence the outside world. I also decided I wouldn't associate with people who say "I don't like it because I don't understand it or don't know it," and besides, I didn't want to be like them. That experience led to my belief that you should do a lot of preliminary research, and if there's something you don't know, draw it through careful observation so that you don't become someone who despises and disregards things they don't understand.

Sperm whale

This is a sperm whale. I was trying to freely draw an impactful scene from the story the teacher read to us, but it wasn't the image of a whale that everyone else had in their minds, so those children were convinced I had drawn a monster.

A Life in Visual Communication

■ **You started doing *doujinshi* or self-publishing your work in junior high, so you were able to share your ideas that way. Did your drawing style change because of that?**

RS Up to then, I was drawing using only my own knowledge, but I got influenced by my elementary school classmates to start drawing anime and game characters. When I was in the 6th grade of elementary school, I realized the only thing I didn't get bored of was drawing pictures and I really thought if I didn't base my life on drawing, I'd die. I wasn't thinking about a career yet, but after wondering how I could improve my skills, I decided *doujinshi* was the way. I wanted to create pictures that could be conveyed to people and practice making them in a consistent style. At the time, I mostly only drew the Pokémon Charmander.

■ **So you thought *doujinshi* would be training for conveying your thoughts through pictures?**

RS That's right. Also, my dad's family home was a dairy farm in Iwate, so it gave me a good opportunity to see the difference between cows and humans close up. Cows end up being slaughtered for meat, but during their lives they are treated and raised with more care than humans. I think that way of separating humans and animals had a significant influence even on my current creations. They had a different existence to humans, but there was the sense of that existence being on an equal footing with ours.

In contrast, there was a wild bear that sometimes appeared out by the porch, which taught me there are some lines between humans and animals that can't be crossed and that segregation is to protect both sides. If humans unilaterally use animals just for their own benefit or interfere too much, well, they say cracks will appear. I think humans are interesting and I will include them in my creations, but they tend to be the bad guys (ha, ha!).

■ **You studied art at high school?**

RS I majored in ceramics. Apart from English, Japanese, and physical education, all the courses were art history and practical skills for drawing, so it was like heaven for me. I'd been seen as an oddball in junior high and I didn't really want to go to high school, but my grandmother and aunt strongly recommended that I go, so that was the first time I did my own research and decided where I wanted to study. I met people there who were far better at drawing than me, and my love for drawing that I'd been suppressing up till then just exploded. It was an amazing high school introduction after being denied the freedom and what I

loved in childhood and then spending my early school life suppressing that love out of frustration, while still continuing to draw. But I think that's why I was able in high school to get the idea for *MADK*, which led to my manga debut. When you're in the middle of a tough problem, you can't get to the bottom of it, but there are many things you can understand for the first time if you're in a situation where you can be objective.

■ **You chose a good high school. I think you had to relearn drawing from scratch. How was that?**

RS I learned a lot in the practical lessons, but what really stayed with me was art history. I still remember the story I heard about Picasso at that time. When he was 14, the technical genius Picasso realized that even he couldn't convey emotion just by being highly skilled, and that's how he finally arrived at abstract painting. I also sketch a lot before I draw a character, but at the design stage I put that knowledge to one side and think about what it is I want to show. More specifically, if you want to create a powerful image, you should prioritize giving it a powerful form, even if the final form strays from the initial rough sketches. I was definitely influenced by that Picasso story. Incorporating abstraction into pictures is an advanced technique that is only possible for people who thoroughly know the actual form of the thing being depicted. Creating abstraction without knowing the truth makes it just a deception. That's why the fundamentals are so important, because if you have the basics down, your application will be strong too. Recently though, "learning the basics" has come to mean "sticking to the basics" and I feel many students can't move past those onto application. In my case with that problem, I often feel that what I learned in art history is still proving useful. On top of that, you should understand with your heart, and not learn only using your head. That said, I'm only ever doing trial and error to figure out how to form shapes for things with no form, and until I was 28, I was struggling every day because I couldn't draw well enough to just draw the final form without lots of sketching.

■ **You had a hard time?**

RS The reason I don't want to say simply "if you do lots of rough sketches and drawing, you'll get better" is because for two years after I became an employee, I kept sketching and as a result, even though I could capture forms, I realized the pictures that I hoped would convey something significant, often didn't.

While I was searching for parts that were either close to or far from human, I came to interpret the human body as a natural object. From that, even a single lock of hair can be drawn with different styles of line, "like wind," "like fire," "like water" and "like vegetation," and connected to the character's attributes.

Leaf veins. When I learned about the human body in science class, I thought blood vessels were like leaf veins, and when I saw an amoeba, I thought it looked like a nebula in space, so it's from that time onward that I can remember really having fun finding relationships in completely different things.

Acquiring a Broad Range of Skills and Collaborating with Masterful Creative Professionals

■ You were 28 when you were working professionally at the game company, correct?

RS It was great to work at a company. I predicted I'd go freelance in the future, but to begin with, I wanted to learn production techniques and how to earn money, while also studying about society. So I spent my days learning, adjusting and making mistakes, only thinking of how much of myself I could pour into the work I was given. It was thanks to that, even though I couldn't see it at the time, that I could naturally learn how to respond to demands and make suitable designs, and I learned how to work in a team environment and produce good results.

So at work, I focused on drawing what was required of me and producing results. The two years of independent sketching didn't have a significant effect on my drawings, but it did directly link to my ability to illustrate in such a way that can be conveyed to and understood by an audience, which is the basis of a designer's work.

■ So did that affect what you thought about drawing or how you approached it?

RS The way I saw things stayed the same, but it made me realize the importance of having a range of expression. It was amazing to see right there in front of me the process of people with genius-level drawing ability transforming objects into forms that everyone can accept, and it was also amazing to see their designs become products that could be recognized as their art without their having to put themselves out there like independent fine artists do.

For me, Tatsuya Yoshikawa* was a huge influence. He says that he's just pursuing the forms that will please his target audience the most and it's not his intention to make a statement with his art, but each drawing is instantly recognizable as Yoshikawa's.

It reminded me that you don't have to force your own personality or character into a work of art—it can be found in the work automatically. Besides, Yoshikawa usually makes something like 1,000 sketches to create a single drawing. I've seen people hunched over drawing surrounded by huge piles of paper before, but that was the first time I felt awed just by someone's sheer effort. I worked with him for about two years, and while I wasn't working directly under him, he was really good to me. I asked him many times to look at my drawings, but of course when you're at Yoshikawa's level, he doesn't say anything too critical.

First he'd ask me what I was trying to depict or express and when I told him, he'd give me precise advice on how to express it or make it look better to fit the objective. I was really grateful. When I started teaching at a vocational school, shortly after going freelance, his example made me understand how to give advice. True professionals are strict because they live in that world, but they don't flat out dismiss or make fun of other people's drawings. So, if you have the chance, you should show your art as much as you can to professionals and ask what they think.

■ Even a little advice is theoretical, right?

RS That's right. It's often said that if you don't draw for three days, you'll atrophy, but Yoshikawa says it's because you're not using your head. I've explained in this book about the placement of facial parts and if you understand that theory, even if you don't draw for ten days or so, when you do draw, you'll remember it in about thirty minutes. Yoshikawa taught me that all pictures can be summed up in words.

It's said that Yoshikawa dared to abandon the popular drawing trends and relearn basic sketching. He said "drawing trends are short-lived, but the proportions of the human figure haven't changed over the millennia. If you want to work in illustration for decades to come, the fundamentals are important too." When I heard that, my lack of understanding about the value of the basics evaporated, and I quickly understood that it's to gain a universal framework that you can turn to when you are in doubt. That's why I kept sketching every day for two years. It taught me a professional attitude of not being influenced by current trends or the reputation I was getting, but to switch right over to working on something as soon as I knew what I needed. I hope that attitude can be found here and there throughout this book.

Being Accepted by the World of Manga

■ You went freelance after that, but was there some reason or prompt?

RS I didn't quit because I wanted to go freelance. My goal since I joined the company was to only work there for three years, partly because of what my senior colleagues taught me. Ultimately, I was assigned a new game title, and then, just when I thought I'd mastered all the techniques, the company changed its policies. Up to that point, I'd been learning new skills every year, but now I was to stay in a department with a single specialty. After learning that, I decided it was time to move on.

* **Tatsuya Yoshikawa** (Game Creator and Character Designer) Among his other work, he has been responsible for character design in the *Breath of Fire* series and the illustrations in *Devil May Cry*, games both developed by Capcom. After leaving Capcom, he worked with DeNA and then with Oriflamme. He is currently the director of the game and animation production company Wodan.

■ **You've been active since then though?**

RS I knew a time would come when I would quit and I wanted to produce my own drawings, so I continued to work independently during my tenure. When I was 25, I created *MADK*, my first *doujinshi* self published work, which was based on a reconstruction of *Onsa-do*, a work I did in high school. Because of the content, after finishing it, I put it aside for a month as I worried about whether it was fine to release, but Katsuya Terada*, who was a huge influence for me during high school, gave me a push by saying "no matter what you think, the readers are free to think what they will. So if you want to put something out there, put it out." And that's how I was finally able to decide to publish my work. Rei Ishii (the editor in charge of *Jinba*), who was still a relatively new editor at the time, purchased my *doujinshi* and I later heard that she thought, "if this person is properly trained, he could draw manga."

As soon as I officially announced I was quitting, Ishii, who was by then a manga editor, contacted me and it's now been seven years. It's thanks to Ishii for bringing *Jinba* into the world that I can now say I'm a character designer who can publish books like this one. People often tell me how lucky I am to be freelance or how envious they are that I get work so quickly, but for me, it feels like all the "little dots" of my actions suddenly connected in line a few years later. When I think about it like that, I know I made the right choice to go freelance.

■ **It was a huge turning point in your life.**

RS Yes. I drew a full-length manga for the first time. Although I loved drawing characters up to then, when I drew them, even those that I wanted to, I was in self-denial. I couldn't affirm what I was drawing because I was thinking things like, "isn't drawing a character just running away from something else you can't draw?" It's a picture created through a lot of denial, so it's painful and I push myself so hard I sometimes. At companies, I can't design unless I think of all the details, like the character's way of life, the evolutionary theory, the weapons needed for that world, etc.—but I get told that I'm overthinking things. It made me feel like considering the backstory was a waste of time in professional work.

But Ishii and other manga editors loved all of that and found it interesting.

I used to limit myself regarding how much I talked about setting, but here they were asking me for more and more,

which made me think manga was probably best avenue for me. The editors of *MADK* and *The Iron Hero* were the same too. To be honest, it's only been a few years that I've been able to have real confidence in my drawings.

■ **It's like regaining someone like your grandmother who recognizes your ability.**

RS It really is like that. I liked the characters, but for a long time I didn't recognize it myself. I was forever saying, "you can't just draw a character, you have to have a background too." It made me realize though that I would do anything for my characters. If you need a background, give it a try even if you're not that good at it. And you'll find that you can draw it. When I was 13, I was crying while drawing, but now I've been told the encouraging words I wanted to hear from someone back then. As someone who can only draw, getting affirmation like that suddenly opened up my world. I feel that encounter was like destiny and I want to continue cherishing it in the future too.

■ **It's understandable why there is so much richness in the characters and background for *Jinba*.**

RS I'm grateful about that. Now that I look back, there are a lot of clumsy parts, but it's a work that showed me specifically "these are your strengths!", so I have a strong attachment to it.

With the first volume of *Jinba*, I spent a month redrawing it and that's how I learned to draw manga. I think they took me seriously because they trusted that no matter how busy I was at that time, if they pointed out "this part is hard to understand," I would always correct it. I had intended to do only one volume, but while we were talking and answering questions, and I was doodling the characters that appeared, they announced that Volume 2 was being planned. Now I've gone overboard! (ha, ha!)

■ **You're still posting idea notes on social media, which was what led to the serialization to begin with.**

RS That's right. The things I post on Twitter are exactly that. The main one at the moment is *Shinwa no Kemono*, which Ajai appears in as well.

■ **In that case, will there soon be a day when we can read it as a manga?**

RS I wonder, maybe! (ha, ha!)

* **Katsuya Terada** (1963–) (Manga Artist and Illustrator)
He works under the alias Rakugakingu and is highly regarded in Japan and internationally. Along with his manga work like *The Monkey King*, he is also engaged in many other creative endeavors, such as book design and illustrations, games and anime, as well as character design for special effects.

In Closing

Thank you for staying with this to the end.

I have the following few things to say to everyone who took the time to read this book. You don't need to try to be unusual. Ideas are universal. Originality is the moment you realize you like something. The artist is a person and the person viewing the art is a person too.

Were there any characters in this book drawn with the intention of making something completely unique? No, there weren't. Everything I see, research, know and experience becomes one of the many puzzle pieces that go into my creative work, and the characters I create can only be made by putting those pieces together or taking them apart.

When you like something, what is it that you're feeling? That feeling is you, yourself! In other words, original. By going through trial and error to express that, you'll be able to create your own unique lines.

Drawing is not the personification of pictures. Each person who has lived up to now as a human can pick up a pen to draw, so there are as many ways to draw as there are people. However, there are commonalities among drawing styles that can be considered universal, but also an infinite supply of variations that are good.

In this book, I've tried as much as possible not to say a certain way of drawing is wrong. Even if you happened to feel that way about something expressed, that doesn't disqualify a drawing style. I hope this book will help you to find a way to enjoy and be satisfied with your own drawings.

Having a place to begin to means you can feel confident and go anywhere. It's my intention that you use this book as a starting point and reference for when you don't know what to draw or how to proceed.

I hope that someday I can meet the characters you draw. Have a great time bringing your characters to life!

—Ryo Sumiyoshi

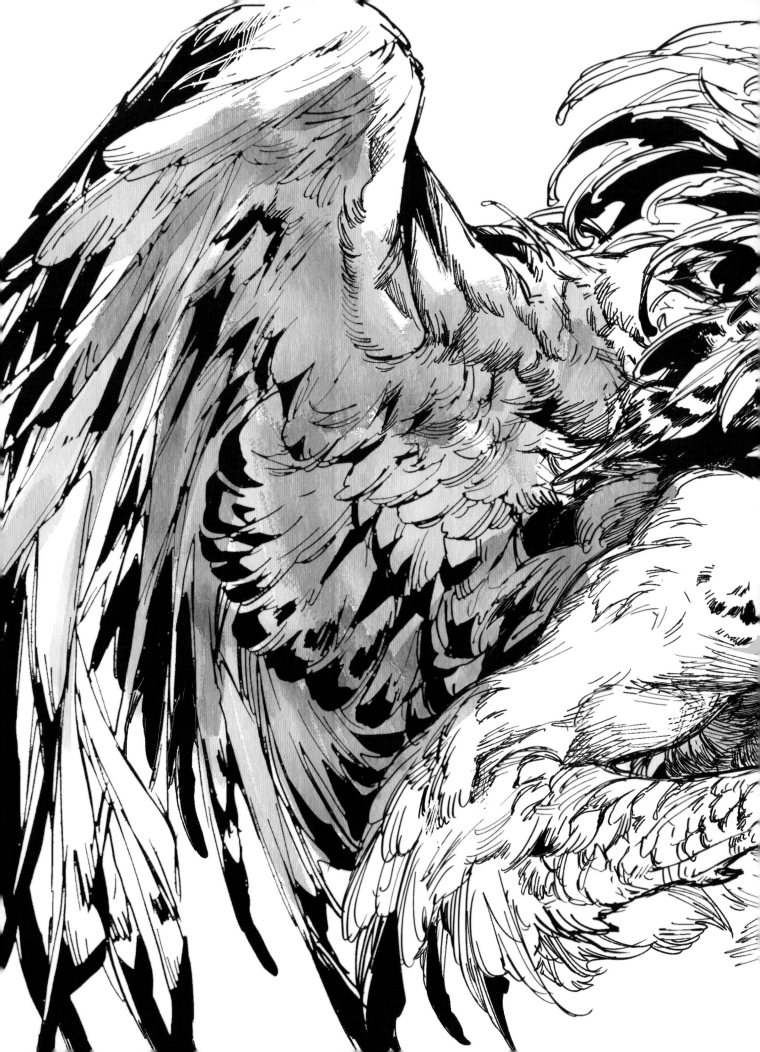

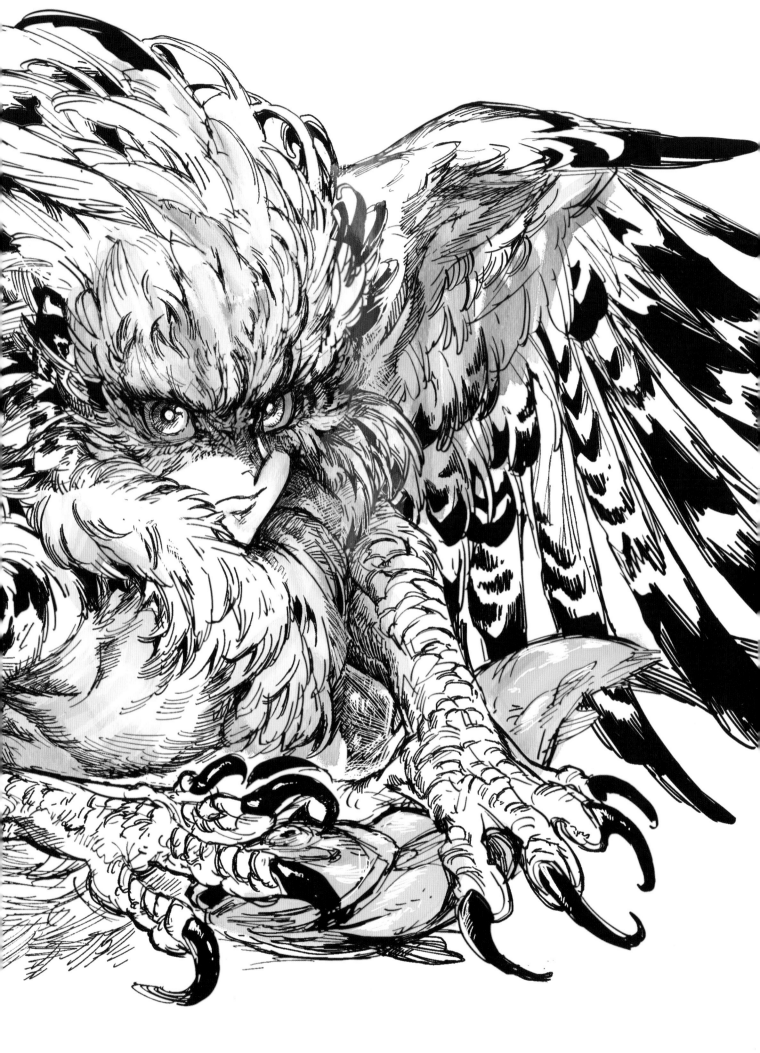

"Books to Span the East and West"

Tuttle Publishing was founded in 1832 in the small New England town of Rutland, Vermont [USA]. Our core values remain as strong today as they were then—to publish best-in-class books which bring people together one page at a time. In 1948, we established a publishing outpost in Japan—and Tuttle is now a leader in publishing English-language books about the arts, languages and cultures of Asia. The world has become a much smaller place today and Asia's economic and cultural influence has grown. Yet the need for meaningful dialogue and information about this diverse region has never been greater. Over the past seven decades, Tuttle has published thousands of books on subjects ranging from martial arts and paper crafts to language learning and literature—and our talented authors, illustrators, designers and photographers have won many prestigious awards. We welcome you to explore the wealth of information available on Asia at **www.tuttlepublishing.com**.

Published by Tuttle Publishing, an imprint of Periplus Editions (HK) Ltd.

www.tuttlepublishing.com

ISBN 978-4-8053-1734-1

JUJIN GIJINKA JINGAI DESIGN NO KOTSU
Copyright © 2021 Ryo Sumiyoshi, GENKOSHA Co., Ltd.
English translation rights arranged with GENKOSHA Co., Ltd. through Japan UNI Agency, Inc., Tokyo

All rights reserved. The items (text, photographs, drawings, etc.) included in this book are solely for personal use, and may not be reproduced for commercial purposes without permission of the copyright holders.

English translation © 2022 Periplus Editions (HK) Ltd
Translated from Japanese by Wendy Uchimura

Printed in China 2212EP

27 26 25 24 23 10 9 8 7 6 5 4 3 2 1

TUTTLE PUBLISHING® is a registered trademark of Tuttle Publishing, a division of Periplus Editions (HK) Ltd.

Distributed by:

North America, Latin America & Europe
Tuttle Publishing
364 Innovation Drive
North Clarendon
VT 05759-9436 U.S.A.
Tel: (802) 773-8930
Fax: (802) 773-6993
info@tuttlepublishing.com
www.tuttlepublishing.com

Japan
Tuttle Publishing
Yaekari Building 3rd Floor
5-4-12 Osaki Shinagawa-ku
Tokyo 141 0032
Tel: (81) 3 5437-0171
Fax: (81) 3 5437-0755
sales@tuttle.co.jp
www.tuttle.co.jp

Asia Pacific
Berkeley Books Pte. Ltd.
3 Kallang Sector, #04-01
Singapore 349278
Tel: (65) 6741-2178
Fax: (65) 6741-2179
inquiries@periplus.com.sg
www.tuttlepublishing.com